MAKING
MOON

A BRITISH SCI-FI CULT CLASSIC

MAKING MOON
A BRITISH SCI-FI CULT CLASSIC

ISBN: 9781789091007

Published by Titan Books
A division of Titan Publishing Group Ltd.
144 Southwark St.
London
SE1 0UP

First edition: October 2019
2 4 6 8 10 9 7 5 3 1

Did you enjoy this book? We love to hear from our readers.
Please e-mail us at: readerfeedback@titanemail.com or write to Reader
Feedback at the above address.

To receive advance information, news, competitions, and exclusive offers online,
please sign up for the Titan newsletter on our website: www.titanbooks.com

A CIP catalogue record for this title is available from the British Library.

Printed and bound in China.

**The author wishes to thank the many people who were so generous with their
time and insights. Without the following this book would not have been possible:**

Duncan Jones	John Lee
Stuart Fenegan	Stephen Howarth
Pollyanna Cheung	Nathan Parker
Sam Rockwell	Robin Chalk
Tony Noble	Karen Dawson
Bill Pearson	Simon Stanley-Clamp
Gary Shaw	Sophie Hunt
Hideki Arichi	Jo Boylett
Clint Mansell	Natasha MacKenzie
Jane Petrie	The author's family

MAKING
MOON

A BRITISH SCI-FI CULT CLASSIC

SIMON WARD

TITAN BOOKS

CONTENTS

FOREWORD
BY DUNCAN JONES AND GERTY

DUNCAN JONES: Ten years, Gerty! Ten Years!

GERTY: Ten years, Duncan. Congratulations.

D: Hey! Thanks, pal. Wasn't just me, though. Lot of people involved in making *Moon* what it is. Tony Noble, our production designer, Hideki Arichi, art director, the amazing concept art of Gavin Rothery, who worked alongside Simon Stanley-Clamp creating the VFX...

G: Sam Rockwell.

D: Well, yeah! Of course. Kevin Spacey as your voice, Nicolas Gaster cutting and Jane Petrie on wardrobe. Sounds like I'm introducing my band...

G: And don't forget Sam Rockwell.

D: You said that. But, yeah. Lot of amazing people. Stuart Fenegan, my crazy producing partner, Gary Shaw, cinematographer extraordinaire...

G: Sam Rockwell, of course.

D: You feeling okay, Ger– Ahhhh! I get it. Very funny. Clone joke.

G: I like to make you laugh.

D: Ten years. You know, the film never opened theatrically in France.

G: Is that so?

D: Yeah. Weird, huh? Did gangbusters in South Korea, though.

G: There is a story behind that, isn't there!

D: We don't need to...

G: You used to date a girl from South Korea. I've heard you say that the story of the film was a metaphor for the sense of abandonment one feels when long distance relationships fizzle out.

D: Well, I'm happily married with two kids now, so suck on that ten-year-ago me!

G: Do you think you've changed a lot in that time?

D: God, yes. I'm... older than I'd like to admit, and I'd say that in that time I've had half a dozen personalities over the years, just due to where I am in life. I think we all go through that.

G: Humans maybe. But that's good to hear, Duncan. I'd hate for you to be stuck making mournful allegories about lost love for the rest of your life.

D: You're having a dig about *Mute*, aren't you?

G: What's *Mute*?

D: You know damn well! That Netflix film. You had a cameo!

G: So I did! Sam Bell made a cameo too, didn't he? His court case after he gets back to Earth.

D: Yeah.

G: Have you ever been tempted to continue the *Moon* story in a sequel?

D: Funnily enough, I toyed with the idea of telling the story of the immediate aftermath of *Moon* as a point-and-click computer game. Someone online had created this wonderful illustration of what a *Moon* game would look like if it were done in the style of one of those old LucasArts games.

G: Like *Full Throttle*. I loved that one.

D: You weren't even around when that came out.

G: I downloaded the remaster.

D: Well, that piece of art stuck in my mind and I started to think, "If I did the game like that, I could make the scale as big as I want, go to town with it... Literally!"

G: I'd play that. Would I have been in it?

D: Of course!

G: More than just my arm passing camera, because I felt a little short-changed with *Mute*.

D: Well, that film wasn't really about you.

G: Maybe it should have been. More people might have seen it.

D: That wasn't funny.

G: Sometimes I like to make other people laugh too. Why isn't there any merchandise for *Moon*? I can't count the times I've been asked where someone can buy a desktop Gerty that checks if you are feeling hungry.

D: *Moon* was a little British indie film. The fact that people even remember it ten years later is a testament to how much it punched above its weight.

G: I suppose. Desktop Gerty would be nice though. I'd buy one.

D: Me too.

G: Maybe on the twentieth anniversary.

D: Gerty, if people still remember and love our little film then, I'll build them myself. At least we have this wonderful book.

G: Very true. Happy anniversary, Duncan.

D: You too, buddy. You too.

OPPOSITE: Robin Chalk (Sam Bell clone) watches as director Duncan Jones and conceptual designer and VFX supervisor Gavin Rothery operate the Gerty model on set.

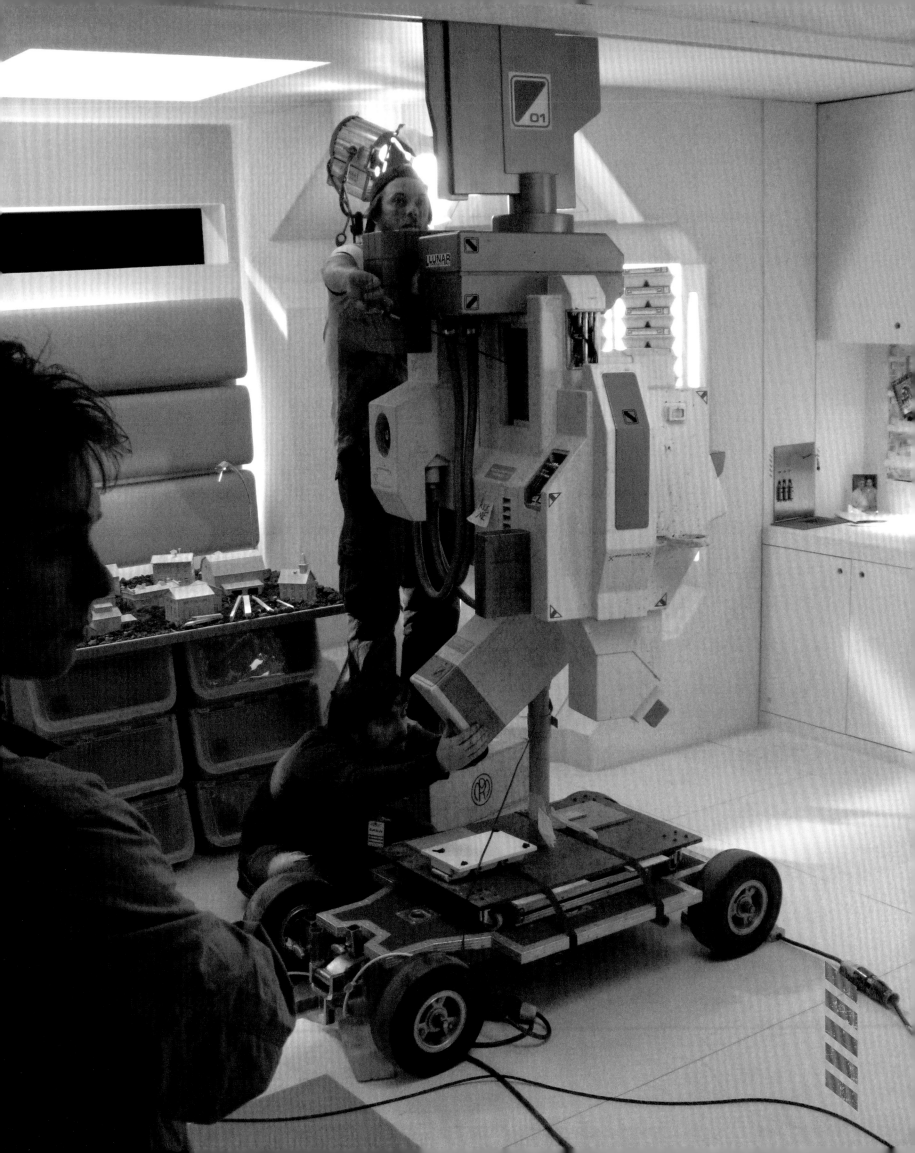

NEW MOON

THE IDEA

NEW MOON
THE IDEA

Duncan Jones knew he wanted to make a film. It was just a matter of how to go about doing it.

Moon is many things. It is a sci-fi film; it is a drama; it is a bold debut and directorial statement. But, above all, it is a personal, intimate movie. Befitting such a tight, independently spirited project, the people who brought it to life were a close-knit group, many of whom shared history before *Moon* had even been dreamt of.

Jones had taken a long route to travel a short distance. He had grown up on and off film sets, had worked at Jim Henson's Creature Shop, on a Tony Scott production as a wild-cam operator, on music videos and been to film school, but had also ventured out into other disciplines and academics. It wasn't until he was in his thirties that he knew for sure that film directing was his calling and he had since been playing catch-up, using every opportunity to get work behind the camera. He had done set dressing for music videos, made low-budget music videos of his own, shot test commercials, he'd even managed to wangle a job as the in-game "cinematics director" at a computer game company, just to experiment with visual storytelling.

BELOW: Duncan Jones on set.
OPPOSITE: Stills from *Whistle* (top), *Blade Jogger* (middle) and Jones' Carling C2 advert (bottom).

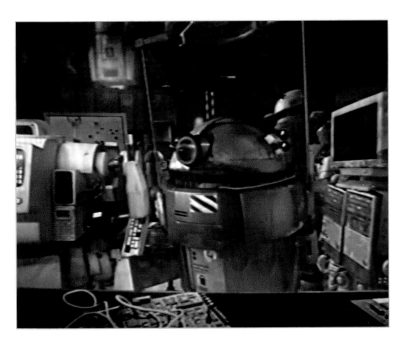
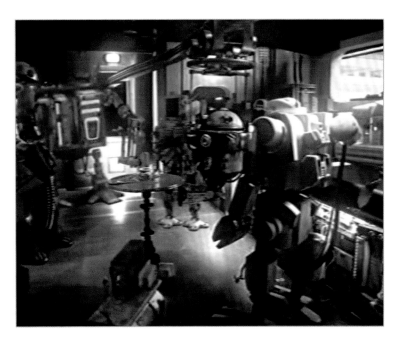

4 INT. COMMS NOOK -- MORNING 4

His hair still wet from the shower, Sam 1 sits before a
COMMS UNIT, dressed in a "Lunar Industries" boiler suit, a
zip up the front, colorful patches sewn into the arms. He
begins to record a message.

 SAM 1
 Tess. Hi. It's me. How are you,
 sweetheart? It's the morning
 here. I'm just about to sit down
 with Gerty for breakfast, go over
 the day's itinerary. He sends his
 love.

As Sam continues his message, we are given a TOUR of the
mining base. Beginning with:

5 INT. MONITORING STATION -- CONTINUOUS 5

This is where you want to be if the shit hits the fan. The
base's equivalent of HQ. A wall of computers and flickering
digital displays.

 SAM 1 (V.O.)
 Everything's fine up here.
 Ticking along, slowly! I found a
 bug on one of my plants
 yesterday! What the hell?! A bug!

6 INT. RETURN VEHICLE -- CONTINUOUS 6

A small space craft attached to the base. It is essentially
a tiny room with a coffin like, sealed bed in the middle of
it: a cryogenic POD with an array of complicated controls
surrounding it.

 SAM 1 (V.O.)
 Yeah. Get's a little dull up here
 sometimes. So! Two weeks, huh?
 Yay!

7 INT. REC ROOM -- CONTINUOUS 7

Sam 1 spends most of his time here. It is kitchen and play
room combined. We PICK OUT a television set, an armchair, a
Ping-Pong table, the treadmill.

 SAM 1 (V.O.)
 You ready? I've been running.
 Yeah. Trying to, anyway.
 (MORE)

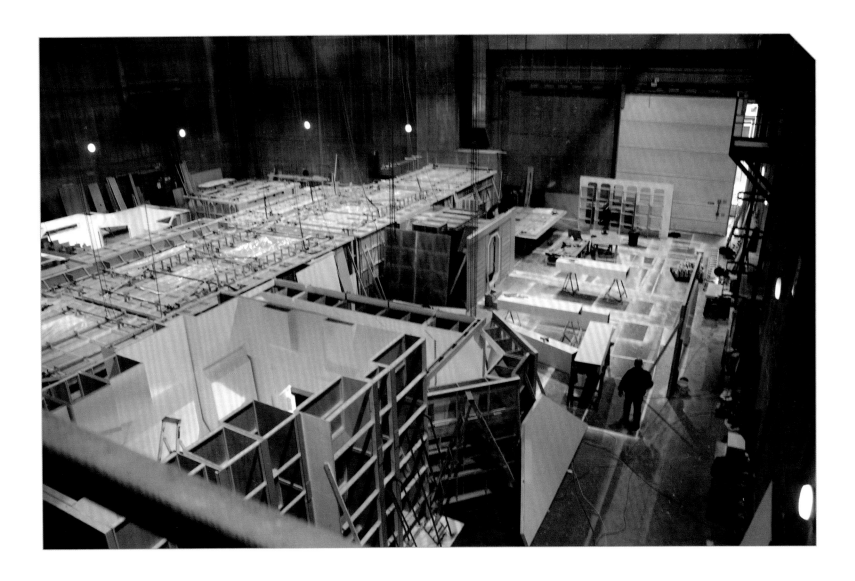

During that period he had met and become friends with some truly talented people. Barrett Heathcote, eventual VFX editor on *Moon*, Hideki Arichi, who would go on to be the film's art director, and Gavin Rothery, *Moon*'s concept artist, VFX co-supervisor and all around visual EMT. Following the death of Jones's grandmother, who had left him some money, these four decided to work together and make a short film that would serve as a calling card for what they could do. Shot on 35mm and with a handful of rough and ready VFX in it, *Whistle* was a taster of feature filmmaking. It was soon after *Whistle* was finished that Jones was introduced to Stuart Fenegan, a fresh-faced producer on the up, equally hungry to make a "real movie."

What these friends and collaborators shared was not only a love of science fiction cinema, but experience in producing work

under both time and financial constraints. All of which made everyone well prepared for mounting a low-budget genre debut feature film.

"Shoestring sci-fi" and certain aesthetics that would later evolve into *Moon* can be seen in some of the earliest work that variations on this core group of collaborators created. There was the student commercial competition for Kodak that Jones directed and Arichi acted as production designer on – called *Blade Jogger* and featuring the legendary Burt Kwouk in a starring role. Jones and Fenegan would subsequently create a futuristic advert for Carling C2 that included a test run for Gerty – something that will be delved into later in the book.

It was on adverts such as these that Jones and Fenegan gained a great deal of the hands-on experience that they would need for feature filmmaking.

OPPOSITE: A page from Jones's shooting script, with continuity markups.

ABOVE: The moonbase set under construction.

"I'd been working for a few years making really, really low budget stuff before I did an ad for Trevor Beattie," recalls Duncan Jones. "He invited me to join his new company at the time, to write and direct ads. The first job I did for the agency was a French Connection ad with these two women fighting." This 2005 commercial was both the first shot for Trevor Beattie's BMB (Beattie McGuinness Bungay) and also Jones and Fenegan's production company Liberty Films. It was the start of what would be roughly two and a half years of collaborations between Liberty and BMB.

"It wasn't that long, but it was long enough for me to learn, try out and experiment on a technical level," continues Jones. "I ended up working on some larger commercials. For Heinz Ketchup we wanted to have a plant that grew out of a tomato – it was interesting special-effects work, and it gave me the opportunity to work with The Mill in London, who do a lot of special effects commercials, and understand what it is you need to know, and how you need to break up shots into various plates in order to make things easier for the VFX work. There was a lot for me to learn on that front and, obviously, when we did decide we were going to just go for it and make a feature film, Trevor was one of the first people I went to. He had been so supportive of me earlier on, doing those ads. He'd always said when I was ready to let him know."

For any fan of genre film who grew up in the 1970s and '80s, there is a certain type of sci-fi movie that appeals: intelligent sci-fi, with heady concepts, striking design, and filled with character actors. All of which describes the first feature-length script that Jones wrote and which he took to a meeting with on-the-cusp-of-stardom character actor Sam Rockwell.

That script wasn't *Moon* though. It was *Mute*. *Moon* wasn't even a twinkle in Duncan Jones' eye when he met Sam Rockwell in

BELOW: Jones on the moonbase set during the shoot.
OPPOSITE: Costume designer Jane Petrie and Sam Rockwell (Sam Bell) as Sam 1 between shots on the moonbase set.
OPPOSITE BELOW: A transcript of the email Jones sent Rockwell after their first meeting.

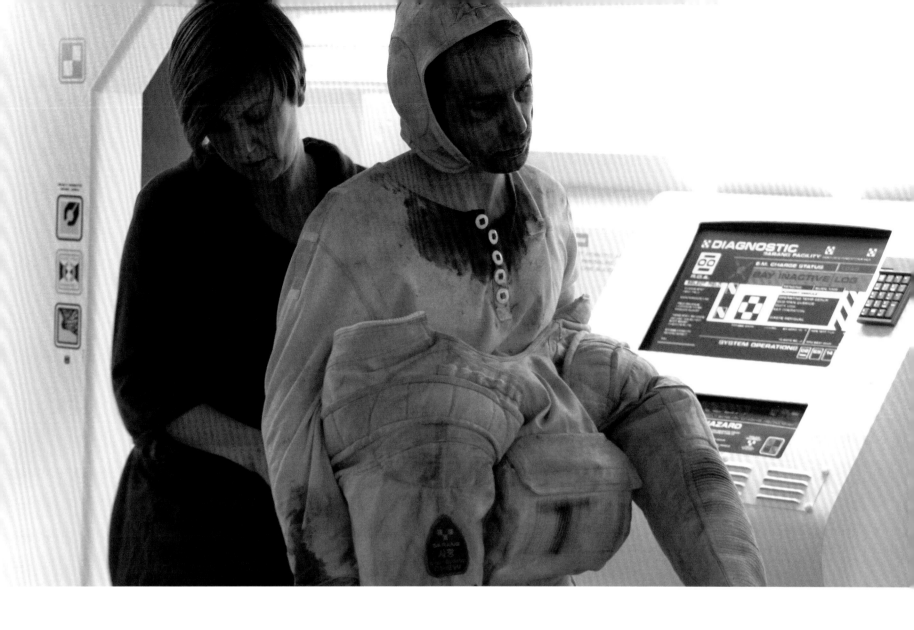

New York to try and convince the unique actor to be in his first film. Jones, a huge fan of Rockwell's work, had sent him the script for his debut sci-fi movie, *Mute*, and Rockwell was being asked to play Duck, one of two disturbing villains in the way of the protagonist, Leo. Although the actor loved the script, he wanted to avoid being typecast as a villain so early in his career, and so tried to convince Jones that he could play the lead. Jones, certain Rockwell wasn't right for the Leo role, said it wouldn't work. Nonetheless, the two hit it off, and even if Rockwell being in *Mute* was not to be (yet), Jones knew that whatever his first film turned out to be, Rockwell needed to play the lead role.

So they talked and, during their chat, like the formation of the moon itself, gravity pulled certain elements together: a blue-collar guy, a 1970s-style sci-fi, and an intimate story about love, hardship, and heart. Duncan Jones boarded the plane back to London with a job to do – come up with a film that combined these disparate pieces.

Dear Sam,

Our little meeting in NY had quite an impact on me. It made me absolutely certain that you were the guy I wanted to do my first feature film with... and as your ears appeared to prick up when I mentioned sci-fi, it seemed obvious to me that the thing I needed to do was to write us a film to make together! That film is "Moon," and I do believe it's something a bit special. I'm sending you a copy of "Full Moon," a photographic record of the Apollo missions. Pull open the gatefolds towards the centre of the book and you will get an impression of what our film is going to look like. It's going to be something quite extraordinary.

All the best, your friend & admirer,
Duncan Jones

Returning to London with a failed *Mute* pitch, Jones was surprisingly upbeat. After discussing with Fenegan and Rothery what he and Rockwell had riffed on, Jones binged on old sci-fi films, many suggested by his encyclopaedically science-fiction savvy housemate Gavin Rothery. With favorites revisited, and some missed classics now watched, Jones wrote a couple of story ideas down – some interesting, some awful, but one worth running with, a treatment for what would become *Moon*.

Films such as *Alien*, *Dark Star*, *Outland* and *Silent Running* had been largely overtaken by big-budget extravaganzas, but the thoughtful, economical nature of those earlier films had made a lasting impression on the team of *Moon*. When the trio of Jones, Fenegan and Rothery started seriously talking about putting together a feature-length film, they weighed up the creative possibilities against the practicalities.

"When we made *Moon* happen," remembers Jones, "Gavin and I had been trying to figure out how it was going to work. Stuart and I started discussing what kind of project we could do if we could raise that kind of money. It was very much the top of the pyramid down as we built it. We worked out what we thought we had available, what kind of project we could write that would appeal to an actor. We had decided to go with an American actor and protagonist to make the film appeal to a wider audience than just the UK. We worked our way that way, downwards, into *Moon*."

Producer Stuart Fenegan remembers the challenge he set Jones in early 2007. "We had agreed, let's do one actor and one location. I said, 'Pick your genre – western or sci-fi,' because we liked both. Duncan's immediate

BELOW: Jones on the moonbase set.
OPPOSITE: On the moonbase set: Jones (top), producer Stuart Fenegan (middle) and Jones and Rockwell.

MAKING MOON A BRITISH SCI-FI CULT CLASSIC

response was to smile and say, 'I've always wanted to do a sci-fi called *Moon*, because there's never been a sci-fi called *Moon* before, and it's right there – we see it from our own planet,' and I thought, 'Brilliant!' I said, 'Next year's the fortieth anniversary of the moon landings. That would be a really good marketing hook,' because I just sort of assumed we'd make the movie immediately! That was it, and Duncan was off writing the outline."

Intelligent science fiction wasn't in the healthiest place in 2007. Outside of the very occasional *Primer* (2004), *Children of Men* (2006) or *Timecrimes* (2007), the genre had gone very cold and Hollywood was certainly not looking to invest millions of dollars in hard sci-fi. Character pieces in such trappings were not being made, and certainly not by first-time filmmakers in the United Kingdom at a major facility such as Shepperton Studios. As a result, Fenegan worked hard to create a package that was as attractive as possible to investors and distributors.

"Having learned as much about the film business as I could moving into *Moon*, I knew that little British indies tended to disappear and not make any money," explains Fenegan. "So what was important to me was to help Duncan make his first feature, to have a successful debut, but 'successful' in my mind was more than just getting it made and people liking it. I wanted the film to at least break even, so that our investors got their money back and also people could see that we had a view to being viable filmmakers. If they got their money back it could mean we would get to make more films! You can make meaningful films and still have them be commercially viable, that shouldn't be a dirty word."

As seemingly few independent sci-fi films being made at the time worked in everyone's favor, so *Moon* as a project was different to anything else being pitched at that time. It was a carefully calibrated package of budget, potential cast, schedule, and a concept that everyone on Earth could identify with.

"As *Mute* taught us," says Jones, "we knew that sci-fi, the kind of sci-fi we wanted to do set on Earth, would have been prohibitively expensive for the small budget we were going to be able to get. But what was lovely about doing a moonbase film instead of anything further out, on a spaceship or anything like that, was that it felt much more near-future, in a sense, because we already have experiences of going to the moon (for those of us who believe that we have). We've already been to the moon and it feels really tangible. You can look up in the sky and see it every night. Everybody globally has a relationship with the moon, which also makes it – even though it's sci-fi and even though there are these strange ideas in it – feel really close and relevant to people. That's why we decided to base it there."

With the movie they wanted to make settled upon and the lead actor in mind, they now just had to find the money, write the script, and deal with the myriad surprises that can derail a debut film. John F. Kennedy had famously promised the world that by the end of the 1960s his country would put a man on the moon; Duncan Jones, Stuart Fenegan, Gavin Rothery and the rest of their team had essentially promised each other that by the end of the following year they would have their own man on the moon – albeit a soundstage version.

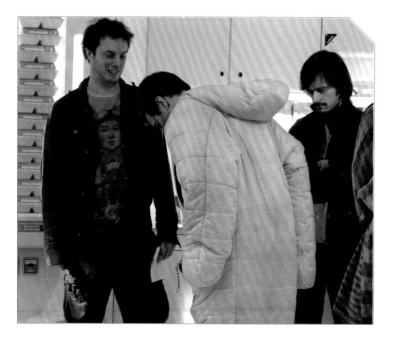

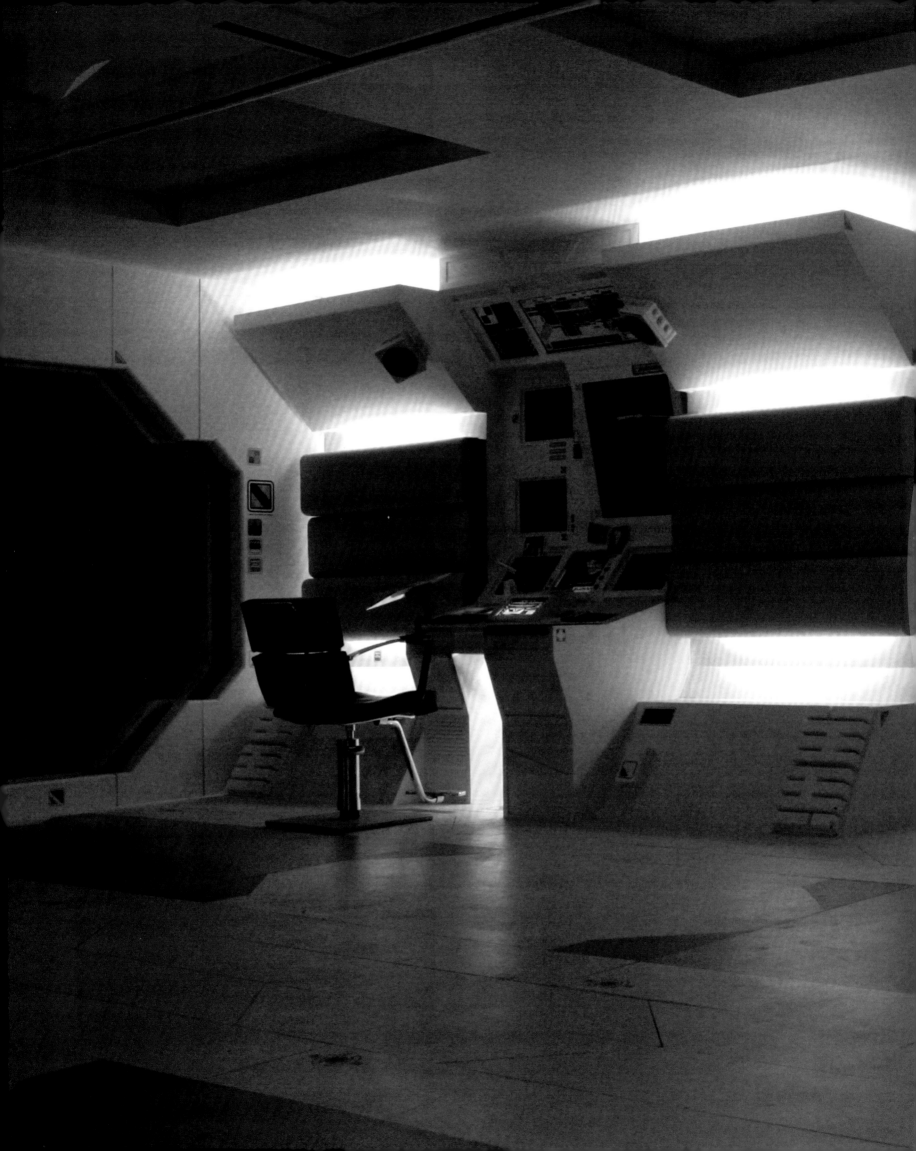

MOONRISE
PRE-PRODUCTION

LUNAR 1 - MAG RAIL

Moon is essentially a chamber piece and a two-hander: a taut, single-location drama. The streamlined vision, the economy of resources, and the clarity of the filmmaking complement one another. Certainly, more money and more time would have been appreciated by all involved on the production, but there is never any sense that the film is restricted by its budget or there is a larger story fighting to get out. The concept of the movie, and the resources the team had, go hand-in-hand. From the very beginning, *Moon* was built as a great story matched by an achievable production and an attractive investment.

Creativity and realism merged in every aspect, with Duncan Jones bringing to bear his pragmatic approach from both his ad agency and video game experience.

"Gavin and I met in the computer games industry," he says. "We used to work at [video game developer] Elixir Studios. With games, you measure twice and cut once. You know what you have available, you build the resources you need. We were thinking *Moon* through that way, too."

It was early 2007 when Jones worked on the story, building it from an outline into a five, ten, and then twenty-page treatment. This was being done in his spare time, and both Jones and Stuart Fenegan were conscious of not slowing down development on the film whilst juggling their day jobs.

"Stuart and I had just received a big commercial that we had to do, but we really wanted to move forward with the film," explains Jones. "We knew we were going to be out of the loop for the next two to three months, working on this commercial. So we wanted to bring someone in. We needed someone good, willing to take my pretty detailed treatment and expand it out into a full screenplay."

ABOVE & OPPOSITE TOP: Set designs for the communcations bay and adjacent area and for Sam's living quarters in the moonbase.

OPPOSITE BOTTOM: The sleeping area section of Sam's living quarters in the final set.

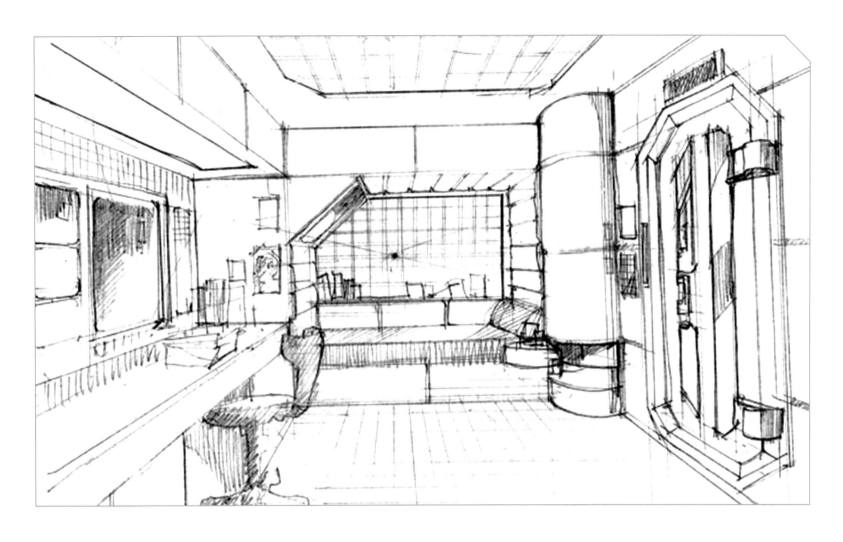

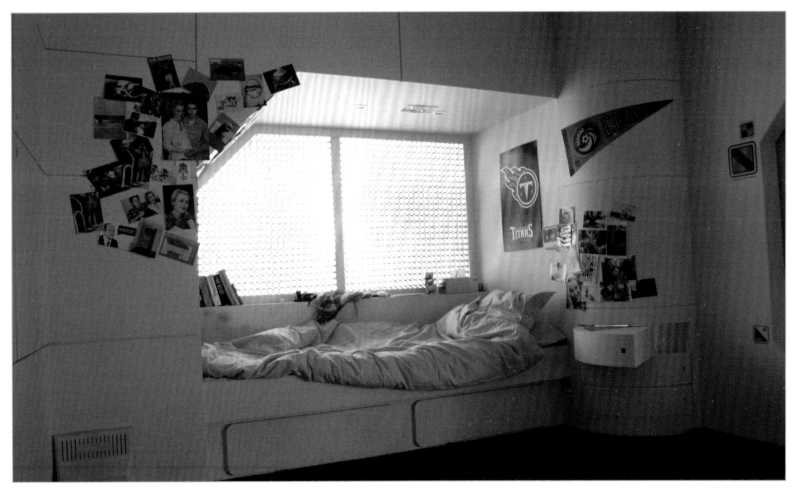

It was Fenegan who found the film's credited scriptwriter, the man they entrusted with putting the meat on the bones.

"I had read a script of Nathan Parker's which I really liked [based on Ken Bruen's novel *Blitz*], and Nathan had just moved back from America to London, so he was kind of looking to meet new people and help on new things. He was available and was a level of writer that was really good for us."

Things were moving fast, with May 2007 being a crucial month – when Parker came on board and the script began to take shape.

"I had just signed with a new agent at Independent Talent and *Moon* was literally the first project she brought to me," recalls Parker. "I was sent Duncan's treatment first, then met up with Duncan and Stuart to talk it over. That first meeting consisted of Duncan and Stu hearing my thoughts (or 'take') on the treatment, but I also remember asking a lot of questions. One thing I remember about that first meeting was Stu saying: 'We don't have a lot of money to pay you, but the great thing about this project is that it *will* get made.' Well, nine times out of ten when you hear that in the film industry it's complete rubbish – and you might even tell yourself to 'run away!' – but wouldn't you know it, Stu's statement turned out to be completely true. I'm really glad I didn't run. After the meeting I went off and wrote a couple of pages on how I saw the movie. After reading the document Duncan emailed me and said: 'Mate, this brought tears to my eyes.' The next day my agent told me I'd landed the job."

As huge a part as money and scheduling played in getting the film underway, of equal importance was personality match – that everyone involved had the same ideas and attitudes or, where ideas diverged, that they did so in a way that elevated the project.

BELOW: The moonbase set under construction.

OPPOSITE: Set design and final set for the medical bay in the moonbase.

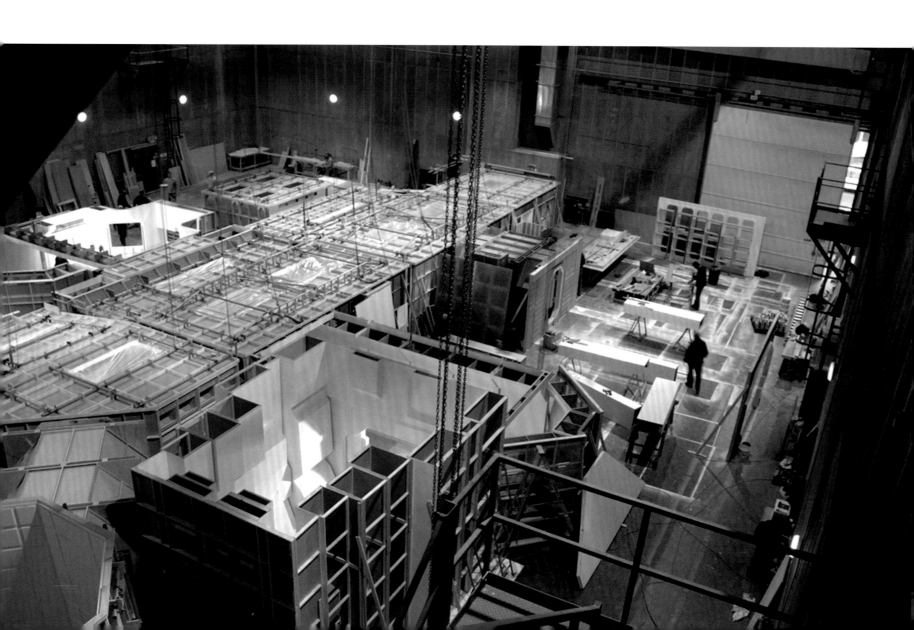

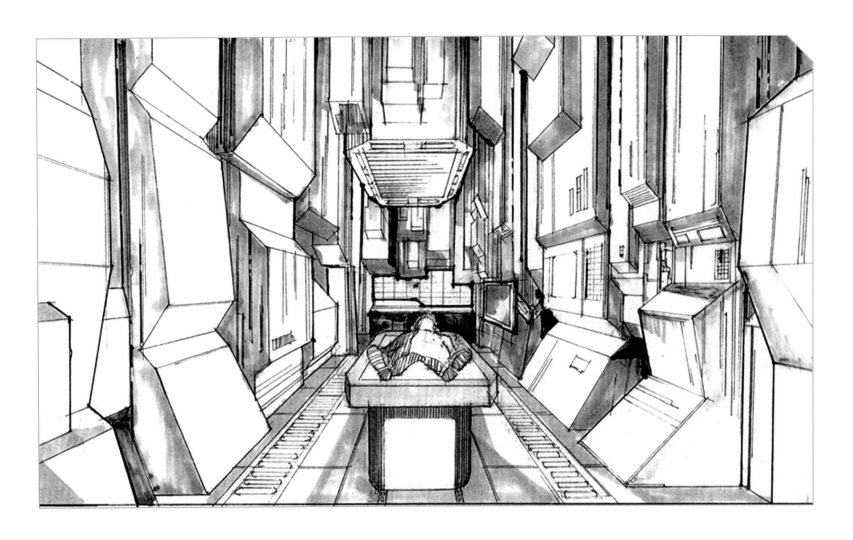

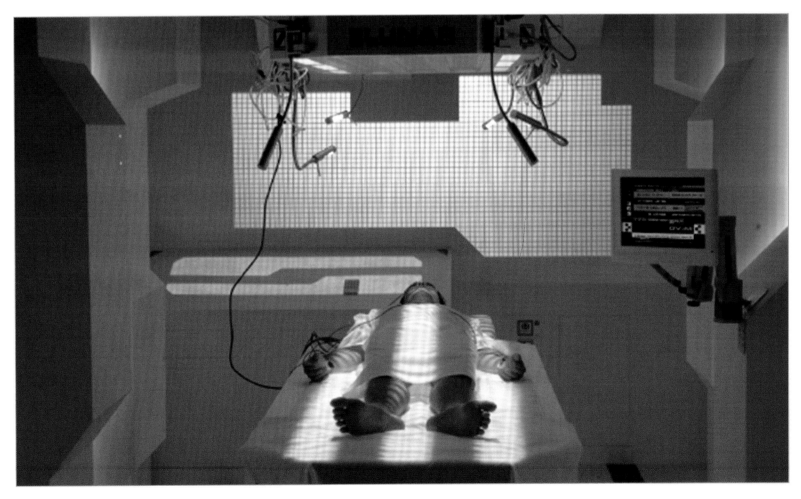

"In that first meeting with Duncan and Stu I asked Duncan why he wanted to make the film," continues Parker. "He replied, 'I want to know what it would be like to meet yourself.' His response was important for a couple of reasons. First it gave me a direct [thematic] route into the material, but it also told me that, although this movie is set on a moonbase and there are clones involved, it was going to be a serious film. You can imagine a different version of *Moon* where the clones are trying to kill each other, chasing one another around the base with guns, and at one point even awakening the clone army down in the secret basement. Well, Duncan had no intention of making that kind of film, which was definitely good news."

While Jones and Fenegan were busy with commercials work, Parker hunkered down and created a screenplay. It took him approximately a month to craft a first draft. "I seem to remember this being difficult for Duncan, as *Moon* was his baby," Parker observes, "and it must have felt a little bit like giving away your child to a relative stranger for a few weeks. I wanted to get the whole script down from beginning to end before sharing it with him, as opposed to sending him scenes or sections as they were written. This is just the way I prefer to work. I remember at least one check-in from Duncan during the writing of that first draft. He was dying to know how things were going."

BELOW: Rothery and Jones on the moonbase set during shooting.

OPPOSITE: Script notes Jones sent Nathan Parker on the first draft script.

SAM ARC

Hi fellah... this is a rough idea as to how we could integrate a bit more tension into the SAM relationship over the course of the film. Though I think there will be a lot of re-writing involved, I think most of it could be weaved into the pre-existing structure... I also think substituting this for what we have could help increase the action and prune down some of the more lengthy expositional conversations. What do you reckon?

SAM is seen to be a pretty decent, well-rounded guy, who is obviously highly frustrated by his predicament, but is doing his best to maintain his cool. When he does get angry, we can see that he makes a conscious effort to control it, and when he is really furious, he relies on breathing, counting and/or other techniques to calm himself down. What particularly winds him up is the fact that the lunar sat communications module has been down for his entire three year shift, and any conversations about that are opportunities to see him really struggling with his temper.

When **SAM 2** has been woken up, and is still alone in the base, he becomes furious to find that Gerty has authority over his base access and that he is not allowed to investigate the harvester. His fury spurs him on to do something slightly mad, but effective, and he stabs at some interior environmental controls to make Gerty have to let him go outside and investigate if they have been struck by micro-meteorites.

(NEXT SECTION COULD FIT SOMEWHERE BETWEEN PAGES 37 - 52)

The SAMs make a tentative start trying to get on. Play ping-pong. Shoot the shit...

But soon enough, the two angrily argue about who is the original. **SAM 2** argues that if there are two of them, there may well be more... somewhere in the base! **SAM 1** thinks the proposition is ridiculous. **SAM 2** angrily insists he will prove it, and storms off on a search of the base, flipping furniture, hunting for a hidden access panel.

SAM 1 follows him, watching him as he goes. He tries to convince him to just relax, as a rescue ship will soon be with them to sort this weirdness out. He tries to block off SAM2s path as he makes his way to the wooden village...

SAM 2 is not going to be stopped and the two **SAMs** get into a scuffle. **SAM 1** comes away from the struggle with a bleeding ear and mouth, and pretty bad bruising. **SAM 2**, still pissed off storms away and gets to grips with "searching" the wooden model

SAM 2 destroys the wooden village in his search. This point is the nadir of their relationship. **SAM 1** is quite scared of **SAM 2** at this point. Maybe he talks to Gerty about his fears.

BREAK (NEXT SECTION COULD BE A REWORKED 54 - 56)

SAM 2 is desperately depressed... **The two SAM's** talk. It is tense. **SAM 2** apologizes for injuring **SAM 1**. He has a temper. He needs to do something about it. **SAM 1** agrees. **SAM 2** makes a good case that the rescue mission is not coming to save them. They're going to be terminated. **SAM 1** thinks that's crazy (but still wants to know who the hell they are...)

(NEXT SECTION COULD FIT SOMEWHERE BETWEEN PAGES 62 - 63,)

SAM 1 searches the computer records and sees the footage of the previous **SAMs**. He keeps looking and sees how they were incinerated in the return vehicle. All of a sudden SAM2s paranoia doesn't seem quite so far fetched!

SAM 1 investigates the return vehicle. He finds ash in one of the creases in the seats. He also finds a hidden panel in the floor that leads to a ladder going down...

(NEXT SECTION COULD FIT SOMEWHERE BETWEEN PAGES 78-84)

SAM 2 feels guilty, and sets about trying to repair the wooden village. **SAM 1** finds him doing this and appreciates the attempt to make peace. He joins him. **SAM 1** tells **SAM 2** he thinks he is right about the return vehicle... and that he has found the secret clone room.

From this point they are pretty much on the same side, with the tension coming from the impending arrival of the rescue mission.

How things were going was Parker figuring out his own approach to someone else's idea. Parker does not come from a sci-fi background and, although he watched *2001, Blade Runner, Alien, Silent Running,* and *Solaris* in order to prepare, he decided to focus in on the story and character rather than the genre elements. This weighting of inner life rather than outer space defines the whole film and would go on to be a huge factor in why it works so well.

"I probably approached it more as a character piece," confirms Parker. "To me it didn't matter that Sam is on the moon; the fact is he is somewhere remote and isolated (it could be Antarctica) and more importantly he was away from his wife and child. I tried to put myself in Sam's shoes as much as I could and approach the material as if the events were happening to me. I also tried to build Sam out as a character, giving him a past and

childhood; in short, a full *life* before his time on the moonbase. I knew that making Sam a real character, and one we can connect with, was crucial to the film."

With the film crystallizing on the page, Jones and Gavin Rothery immersed themselves in moonbase concept designs, while Fenegan set about accruing the finances they needed to actually make the movie. There had never been any doubt in their minds that *Moon* needed to be treated like the canon of sci-fi movies they so admired: shot on soundstages, with the proper resources and regulations; not filmed in Jones's garage over the course of years. There had also never been any doubt in their minds that the film would be made, and this confidence ("Naivety," Fenegan calls it) saw Fenegan raising funds, booking studio space, and signing up crew. To all onlookers, *Moon* was a *fait accompli*.

BELOW: Jones on the moonbase set with the SPROG programmable camera system.

OPPOSITE: 3 of the NASA Apollo mission photos included in the presentation for potential *Moon* investors. Clockwise from top left: Saturn Apollo Program (Apollo 15); Astronaut David Scott on slope of Hadley Delta during Apollo 15 extra-vehicular activity; Astronaut Charles Duke photographed collecting lunar samples at Station 1 (Apollo 16). *Image credits: NASA.*

PAGE 28: A page from Jones's shooting script.

PAGE 29 TOP: Behind-the-scenes on the moonbase set.

PAGE 29 BOTTOM: Costume design for the spacesuit.

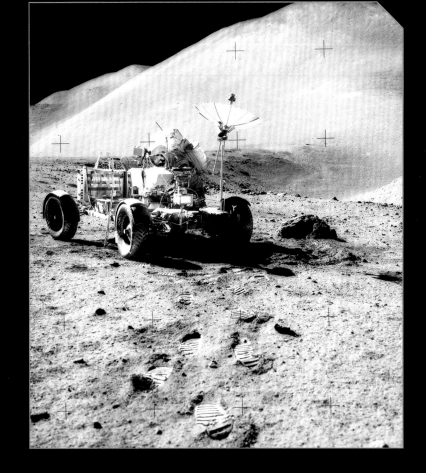
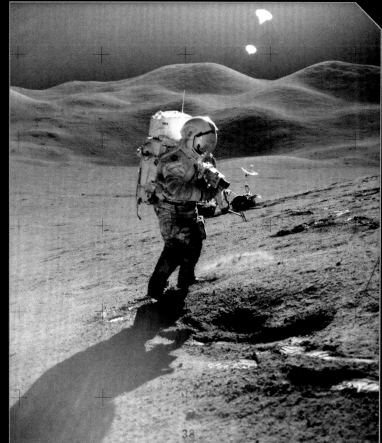
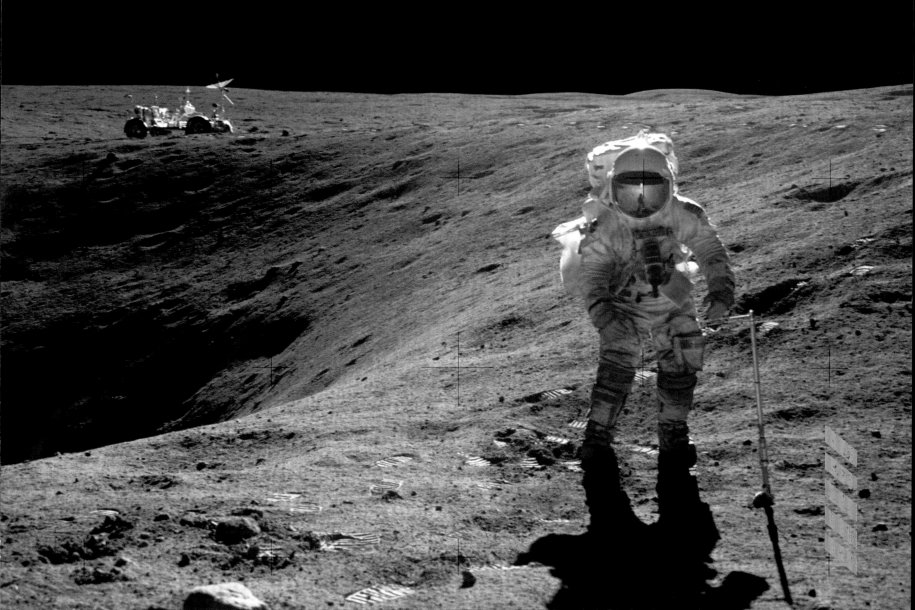

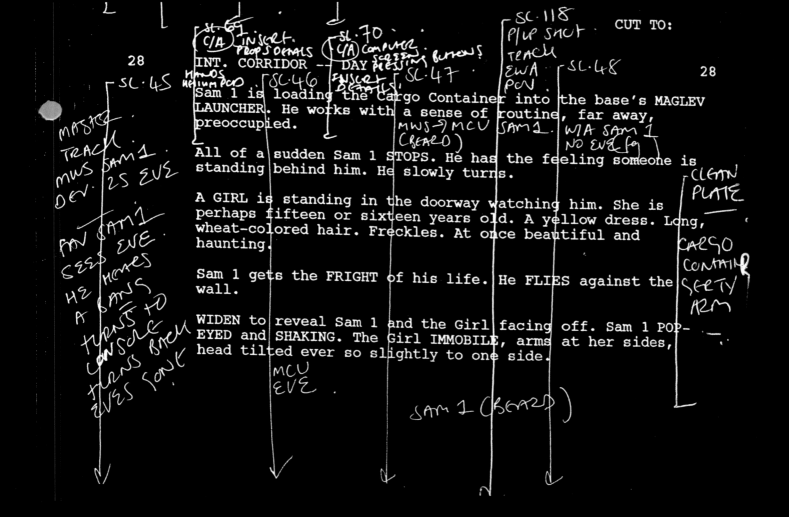

INT. CORRIDOR -- DAY

Sam 1 is loading the Cargo Container into the base's MAGLEV LAUNCHER. He works with a sense of routine, far away, preoccupied.

All of a sudden Sam 1 STOPS. He has the feeling someone is standing behind him. He slowly turns.

A GIRL is standing in the doorway watching him. She is perhaps fifteen or sixteen years old. A yellow dress. Long, wheat-colored hair. Freckles. At once beautiful and haunting.

Sam 1 gets the FRIGHT of his life. He FLIES against the wall.

WIDEN to reveal Sam 1 and the Girl facing off. Sam 1 POP-EYED and SHAKING. The Girl IMMOBILE, arms at her sides, head tilted ever so slightly to one side.

Liberty Films © 2007 - Version 2.8 Shooting Script 2 11th Dec 07
BLUE REVISIONS 17/1/08 12.

There is a loud clicking and the lights briefly dim. The Cargo Container is fired into space with a TERRIFIC CRACKING noise. It distracts Sam 1's attention, breaks his stare...

And just like that, the Girl is gone. Sam 1 is just staring at an empty doorway. Nothing there.

Sam 1 is baffled. Had to be his imagination. Had to be. After a few seconds he shakes his head dismissively and continues working.

CUT TO:

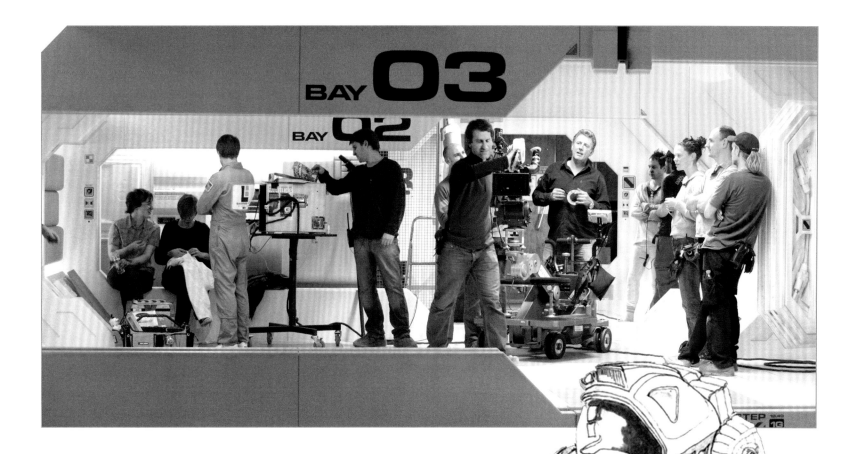

"We were just going balls to the wall, assuming it was all going to be fine," confirms Fenegan. "We got to the stage where we had all the moonbase designs and lots of beautiful photography from this book called *Full Moon*, which has these amazing 70mm photographs from the Apollo moon missions. We put this package out to potential investors who we had met from our time in commercials. But we couldn't book anything or start any work in earnest until after I set up the EIS investment. An EIS is basically a tax-incentivized scheme behind high net worth individuals, so if the movie's successful, brilliant, but if the investment is unsuccessful then some of the losses can be written off against capital gains tax. It's a good way for small indie films in the UK to benefit from investment.

"I was pitching for distribution until the eleventh hour, during the set construction," Fenegan continues. "We were able to start work on the set because the EIS investors – first Trevor Beattie, then Trudie Styler – generously and bravely gave consent for me to start spending their investment without having officially closed the full finance and distribution of the film. There was a huge risk they wouldn't see their money back, or even a film at all, until I secured distribution and, with that, the final section of the film's budget. But because of their investment and belief, we were able to have something real to show distributors. Duncan and I were walking in there, fairly experienced commercial people, but we'd still never made a movie before. The fact that we'd never made a movie before didn't really give anybody a chance to pause, because we had a presentation and set photography of us starting to build the set at Shepperton Studios."

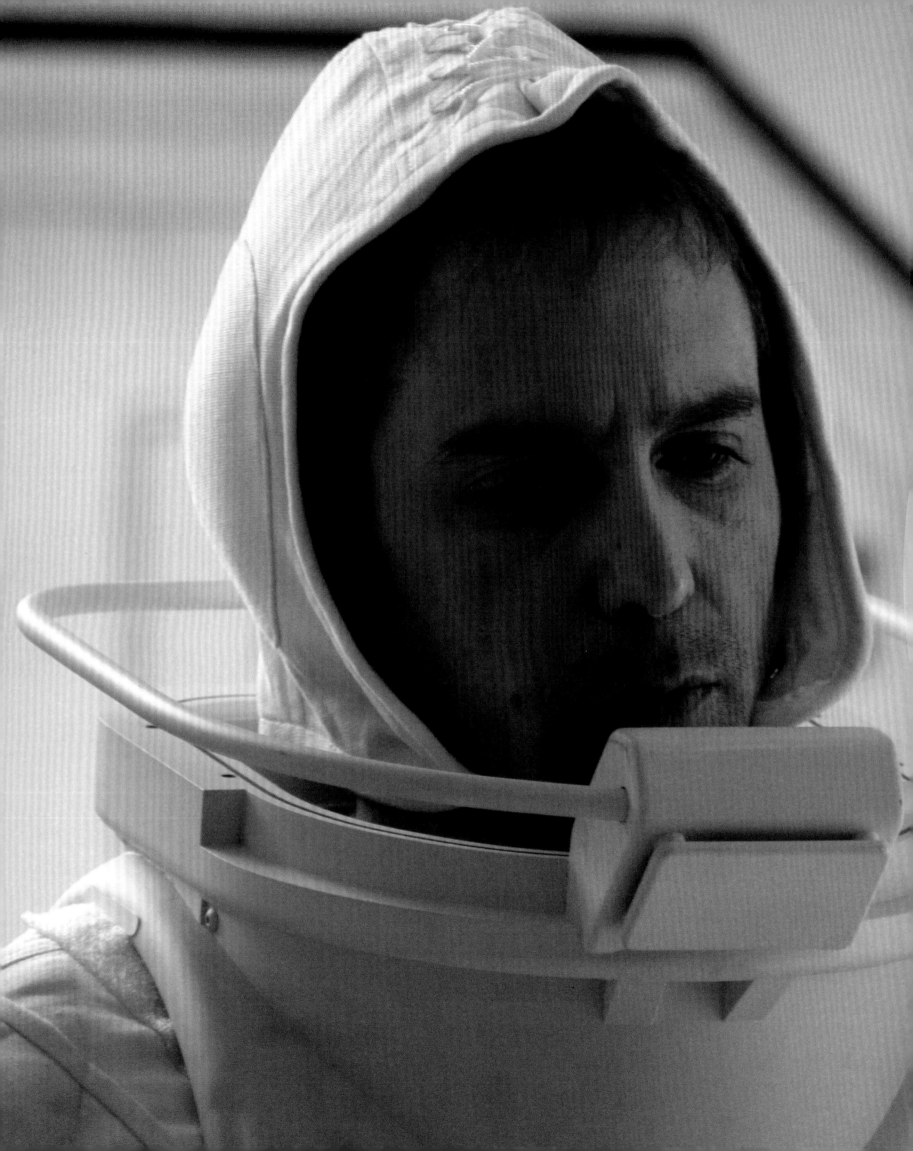

I'M THE REAL SAM

SAM ROCKWELL'S PERFORMANCE

I'M THE REAL SAM
SAM ROCKWELL'S PERFORMANCE

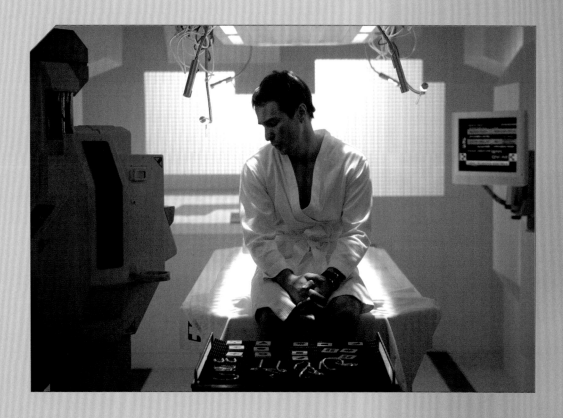

"**S**am was absolutely the star," says Duncan Jones, confirming that from the ground up the film had been constructed with Sam Rockwell in mind for the lead role.

By the time *Moon* was waxing, Rockwell had already established himself as one of Hollywood's premier character actors, leading offbeat films such as *Confessions of a Dangerous Mind* and *Lawn Dogs*, or stealing scenes in everything from *Galaxy Quest* to *The Assassination of Jesse James by the Coward Robert Ford*. It was an incredible bedrock on which to build everything else. "Sam is open to doing a film with us!" Stuart Fenegan recalls their thinking and their starting point. "A first-time director and first-time producer. But he wants a challenging role

and he wants to play the lead."

Moon was a bespoke project. Or, as Duncan Jones puts it, "What actor can pass up the opportunity to play all the roles?"

Nathan Parker had delivered a second draft of the script and this is what they sent to Rhonda Price, Sam Rockwell's agent at The Gersh Agency. Price felt the project was a good fit for her client, but getting his formal commitment would not be quite so smooth. Concurrent with raising funding for the film, agreeing distribution, and finalizing concept designs, Fenegan called Price in New York every Friday afternoon to ask if Rockwell – who was shooting at the time – had read the script and was ready to sign yet. And the weekly answer was "No."

THIS SPREAD: Sam Rockwell as the newly revived Sam 2.

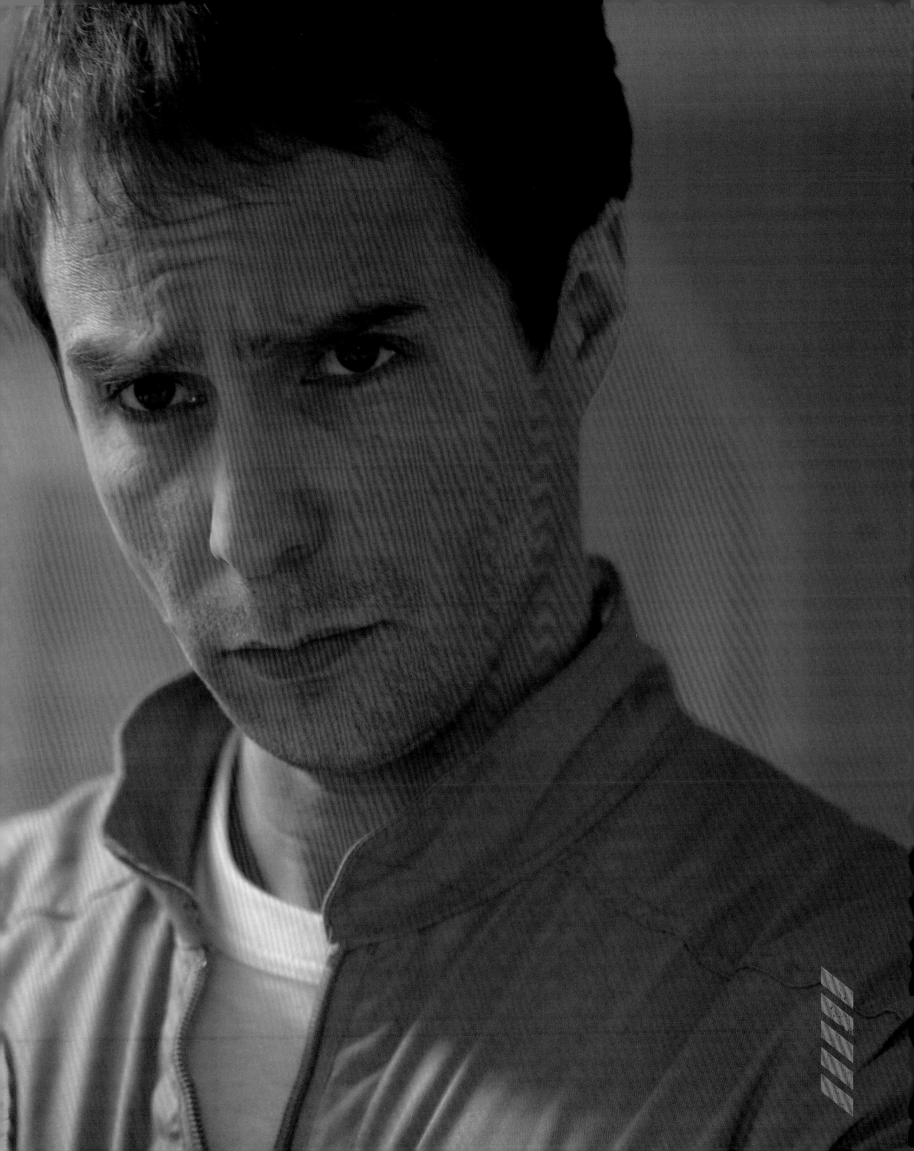

"I was asking her, 'What's Sam's availability?'" relates Fenegan. "This was probably August/September 2007. She said he was available January to March, but then unavailable. So I said, 'Right, we'll shoot in January!' Literally everything was geared towards us starting principal photography in January. I hadn't yet closed the finance. We were out pitching it before Sam had committed, but then I had no choice but to put a clock on the offer. I told them, 'We're getting really close now. If we don't get our leading man we won't get the distribution, without the distribution I can't start building the set, and if I can't start building the set we're not going to have a set ready for January, which is when we're geared-up to shoot.' I said, 'If you don't read the script in the next three days, we're going to move on.' Magically, three days later, when I'm actually having a conversation with an agent about our second choice, I got a phone call confirming Sam was in."

That second choice was acclaimed British actor Paddy Considine, who would have delivered a similarly committed, if different, take on the character. "Paddy is an amazing actor," continues Fenegan. "He has, I think, similar sensibilities to Sam, and it would have been a great British film, but we wanted an American actor in the lead, one that would help give our film the chance of the widest audience possible, and a chance to break out in the US. We were very fortunate to get Sam. He did such an amazing job and it was the performance of a lifetime."

When they got Rockwell's commitment to play the part, what they received was indeed his commitment; his engagement with the role even at script level, showing why he was and is so highly regarded. A sci-fi film that does not rely on effects and action sequences, *Moon* is all about believable character interaction, and Rockwell wanted to take the time to get that right.

"Duncan flew to New York and hung out with Sam for a week," recalls Fenegan. "It was those two and Sam's acting buddy Yul Vazquez in Sam's apartment every day, Sam and Yul running the Sam Bell lines with Duncan, kind of workshopping the script. It didn't change the structure or the goals of the movie, but it was specifically to look at

BELOW LEFT: Rockwell in between shots on the moonbase set.

BELOW RIGHT: Rockwell and Stuart Fenegan on the moonbase set.

OPPOSITE TOP: Rockwell and Jones discuss a scene.

OPPOSITE BOTTOM: Rockwell during the costume test for the spacesuit.

NEXT SPREAD: Rockwell shooting Sam 2 taking out a rover to check the 'Matthew' harvester.

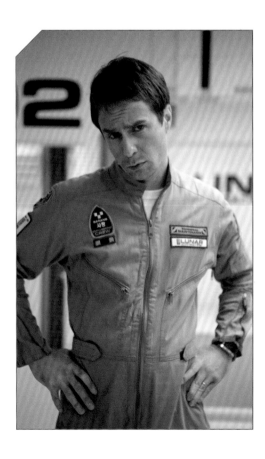

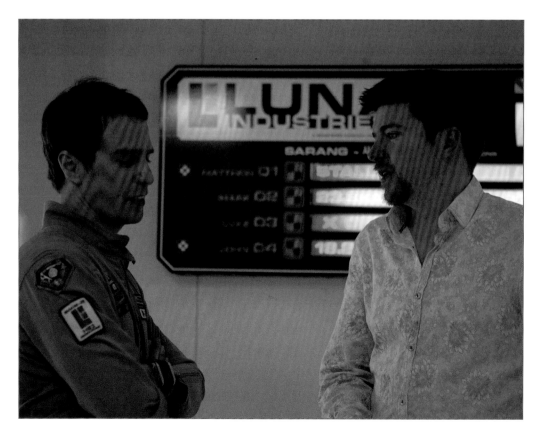

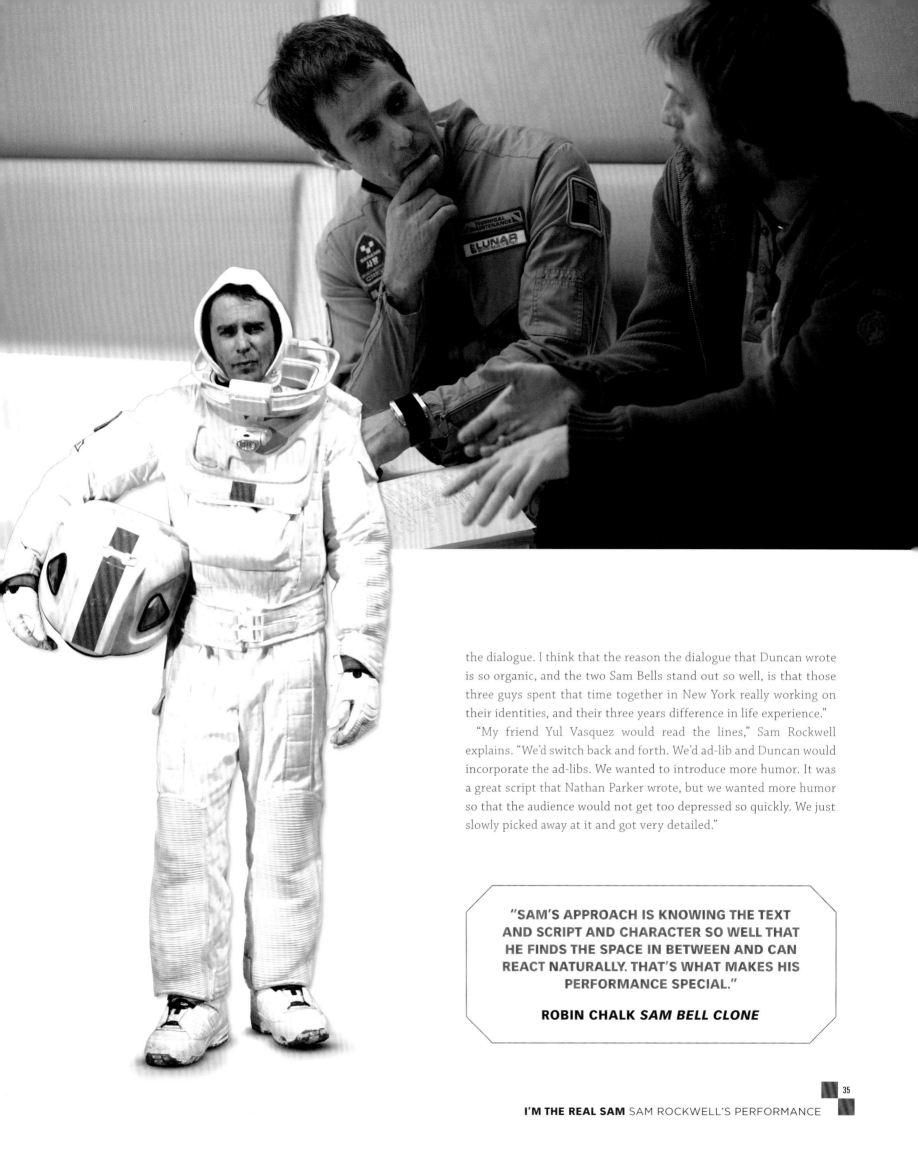

the dialogue. I think that the reason the dialogue that Duncan wrote is so organic, and the two Sam Bells stand out so well, is that those three guys spent that time together in New York really working on their identities, and their three years difference in life experience."

"My friend Yul Vasquez would read the lines," Sam Rockwell explains. "We'd switch back and forth. We'd ad-lib and Duncan would incorporate the ad-libs. We wanted to introduce more humor. It was a great script that Nathan Parker wrote, but we wanted more humor so that the audience would not get too depressed so quickly. We just slowly picked away at it and got very detailed."

> "SAM'S APPROACH IS KNOWING THE TEXT AND SCRIPT AND CHARACTER SO WELL THAT HE FINDS THE SPACE IN BETWEEN AND CAN REACT NATURALLY. THAT'S WHAT MAKES HIS PERFORMANCE SPECIAL."
>
> **ROBIN CHALK** *SAM BELL CLONE*

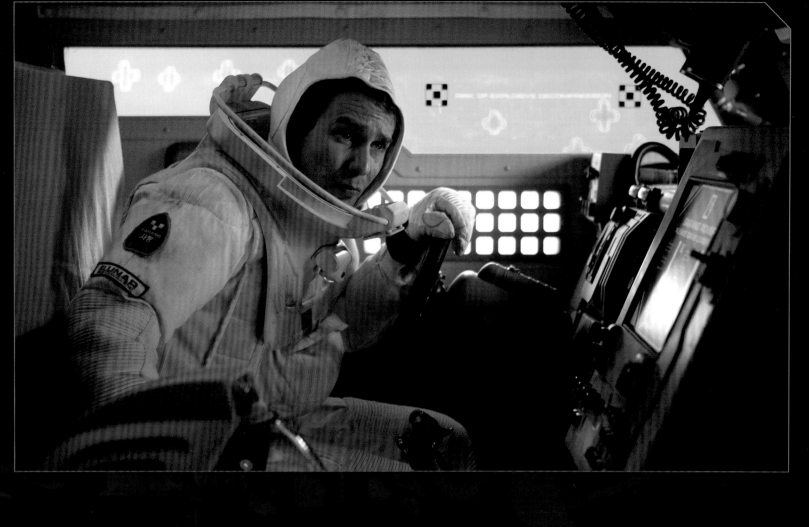

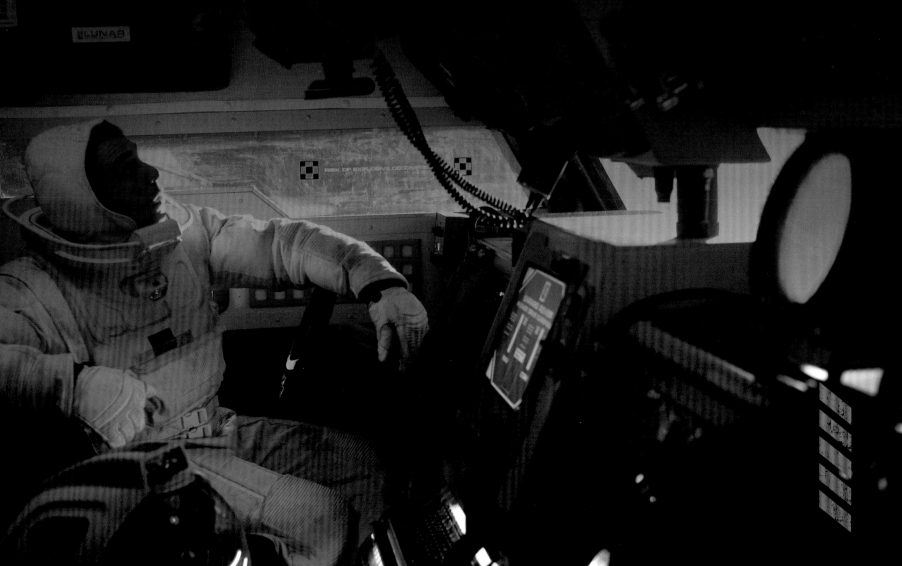

What followed was Duncan redrafting the script with his "fist load of notes," and re-emerging after a month with the shooting script.

They had their script, they had their crew, they had their Sam Bell. Now what they needed was to find another one.

In order to convincingly portray two clones interacting, the production had to find someone to play opposite Rockwell – a mirror for him to respond to. It so happened that earlier that year an actor had been sitting in a bar in Prague when Peter Dinklage came up to him and said, "You look like one of my best friends. You look like Sam Rockwell." That actor was Robin Chalk, and in late 2007 he found himself auditioning for what his agent called, "a weird one... You'll be working with Sam Rockwell one on one." That first audition involved Chalk talking to Gerty. The filmmakers told him to lose the American accent he was using, and then weeks passed before he was summoned to Shepperton,

and told that shooting was to start in two to three weeks, January 2008.

"I was outside the producer's office for forty-five minutes, not sure why I was there," Chalk recalls. "Then Sam arrived from Sundance. We sat next to each other in big, comfy chairs. He had long, shaggy hair, and a beard. I thought, 'I don't look anything like him! I'm not going to get the job.' We were all sat in silence, just looking at each other. Someone said, 'It's eerie.' Everyone was wondering if we were going to be able to pull this off."

At that point Chalk had some fringe theatre to his name, as well as some small TV parts. He was, in his own words, just starting out. *Moon* was his first feature; an incredibly unique and challenging place to start.

"During filming Sam and I would know what scenes we were preparing for, and would sit in make-up together, spending a lot of time together," Chalk says. "We were the only two actors who were on set every day. Kaya Scodelario and Dominique

BELOW: Jones, Gavin Rothery and Rockwell on the moonbase set.

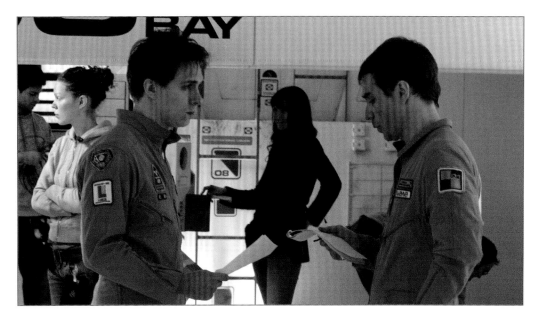

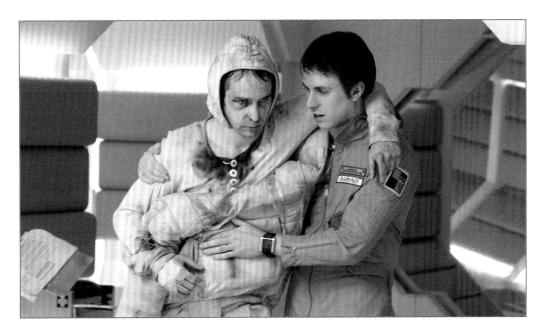

McElligott did three days each; Matt Berry and Benedict Wong did one day each. For Sam and I it was a month and a half in a room together and in the same set. No other locations or venues. Everyone felt really comfortable and relaxed with each other, and that was something Duncan encouraged... The battle was making the performances sync. I felt a lot of pressure. Even though my performance wouldn't appear onscreen, I needed to provide Sam with a performance he could feed off, but I also had to be wary about not pushing him to somewhere he didn't necessarily want to go. His performance was dependent on

what I gave him. I had to match him toe to toe and give him what he needed."

What was required was an extraordinary recall function in both actors. They would perform the scene as Sam 1 and Sam 2, then switch parts, having to remember – after going through a make-up change – how they played the scene previously, not only tapping back into the rhythm and intonation, but also the physical movement of the scene. To get to this heightened level of co-dependence, Chalk and Rockwell called on an acting method called the Meisner technique, established by Sanford Meisner in the mid-1930s.

ABOVE: Robin Chalk and Rockwell on the moonbase set.

"IT'S ONE OF THE WEIRDEST THINGS I'VE EVER DONE. I'M THERE IN BOXER SHORTS WITH THIS LADY, SIMULATING CANOODLING, WITH THE SHEET WRAPPED AROUND OUR MIDRIFF. AT THE END OF THE BED THERE WAS A SIX-FOOT PLATFORM AND AT THE END OF THE PLATFORM WERE SIX BEARDY GUYS. THE CAMERA PANS DOWN OUR LEGS TO SAM ROCKWELL DOWN THERE IN FULL SPACE GEAR WITH A VIEW UP OUR LEGS."

ROBIN CHALK _SAM BELL CLONE_

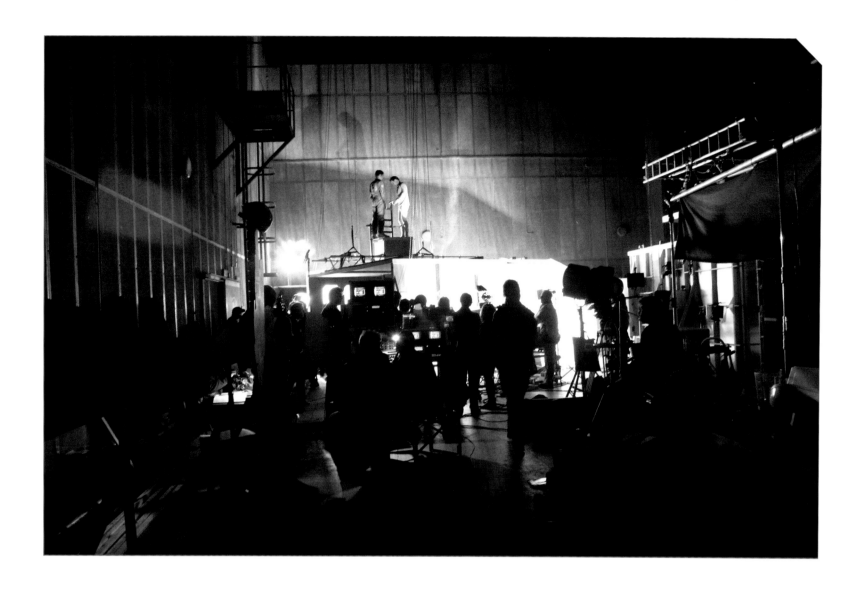

"The idea is making a scene organic," explains Chalk. "It's about repetition. We would repeat a scripted line back to one another and base our performance on what the other said. It depends entirely on reaction. Sam wanted to reach a completely organic place, reading the scenes over and over to make it feel completely natural."

In Chalk's words, it was "an unprecedented situation," demanding a huge level of immersion and commitment every day. "We would do two takes quite simply and loyal to the script to establish a meter and rhythm. Then Duncan would see how we could tweak it and come up with suggestions. At lunch we would switch costume and make-up, then film again. There are two versions of not only every scene, but the entire film. I couldn't speak the second time – it had to sync exactly with Sam's delivery from the first iteration. For the second version of the scene we had earpieces in, playing back the

scene audio from earlier. I would act it, but not vocalize, and Sam could hear himself acting against himself."

To add to the complexity was a need for decisive action and confidence on the part of Duncan Jones. At the end of each morning's shooting, Jones would have to select his favorite take of Rockwell's and that exact one would be played back and performed in the afternoon, otherwise the timings would not work perfectly.

Featuring identical twins and clones in movies has always demanded not only a great deal from the actors involved, but also of the director, who has to go beyond the complex practicalities of shooting scenes to capture genuine emotion. If *Moon* was just a showcase for the – extremely accomplished – technical wizardry of seamlessly shooting doubles, the audience would soon lose interest in the characters as individuals, each on their own journey.

OPPOSITE: Shots from the Sam 2 dream scene.

ABOVE: Shooting Sam 1 and Sam 2 descending into the clone room.

NEXT SPREAD: Pages from Jones's shooting script.

I'M THE REAL SAM SAM ROCKWELL'S PERFORMANCE

 SAM 1
 Aww, you know. Same shit.

A beat. Sam 1's fingers twitching around the red stress
ball, squeezing harder.

 GERTY
 Sam, it might help to talk about
 it.

Sam 1 decides to come clean... sort of.

 SAM 1
 Tess seems -- distant.

 GERTY
 Tess *is* distant, Sam.

Sam 1 shrugs.

 SAM 1
 I mean, she isn't responding to
 things. To my messages.

 GERTY
 What kind of things?

 SAM 1
 (a beat)
 You know. Vacation stuff. I was
 thinking of Mexico or Hawaii.
 Giving her all sorts of ideas.
 Things we could do when I get
 back. Tess never said anything
 about it. Three messages she's
 sent me since...and she's never
 once mentioned the vacation.

 GERTY
 I'm sure she can't wait, Sam.

 SAM 1
 That's not the point. This is
 someone who lives for vacations
 and travelling. I thought she'd
 be crazy about going -- with Eve,
 of course -- we'd take Eve.

 GERTY
 Perhaps Tess didn't receive the
 message?

 SAM 1
 This isn't the only time it's
 happened, Gerty.
 (MORE)

SAM 1 (CONT'D)
I asked her how her dad was doing
on his new heart medication, she
didn't respond to that -- I asked
her when Eve was going to start
nursery -- nothing. Had her
brother got tenure? Nothing.
Nothing.

Sam 1 is really having a go at the stress ball now.

 GERTY
Christopher. Her brother. I
believe he did get tenure.

 SAM 1
He did?

 GERTY
Yes. Professor of Biochemistry,
at Syracuse University in New
York.

Sam 1 is slightly alarmed that Gerty knows this and he
doesn't.

 SAM 1
How do you know that?

 GERTY
You told me. Some time ago now.
 (a beat)
You were very happy for your
brother-in-law. You danced around
the Rec Room.

Sam 1 looks perturbed. For a few seconds he'd eased up on
the stress ball. He starts up on it again now.

 SAM 1
Gerty, have you heard anything
new about anyone fixing lunar
sat?

 GERTY
No Sam. From what I understand
it's fairly low on the companies
priority list right now, with the
Jupiter mission active. I would
imagine it's going to be very
expensive to fix.

A pause. Sam 1 still looks troubled.

 GERTY (CONT'D)
Sam, are you ok?

"I got a chance to speak to Spike Jonze a week or two before we started shooting," reminisces Jones, "just to pick his brains a little bit; if there was anything he experienced or noticed on *Adaptation* that he could tell me to improve our chances of pulling this off. He said, 'Absolutely! You need to really look at a scene and work out which character is driving the scene. Who is making things happen? Then shoot that person first. Shoot that version of the character first, because everything else is going to be a reaction to that. You need to get the instigator, the protagonist of the scene in the can before you know how you're going to react to them.' That was like, 'Of course. Brilliant!' but I wouldn't have known that unless I had experienced not doing it right, or with someone like Spike telling me."

Elaborating on this, Fenegan adds, "Duncan and I watched the Criterion Edition DVD of David Cronenberg's *Dead Ringers*, in which Jeremy Irons plays dual roles. The 'making of' extra was really helpful to us. Our shoot was going to be so tightly scheduled and so complicated that we needed to learn as much as we could to overcome the technical challenges in prep."

Sam Rockwell particularly enjoyed figuring out how to differentiate the clones. "It's fun," he says. "In a sense you are also a director of the scene, because you get to pick the way the other actor reacts to you, because you're the other actor. It's almost directorial, in that you are characters in the scenes. Duncan and I would confer on this and we wanted – as Jeremy Irons put it – contrasting energies. That really worked. We tried loose clothing for the sicker clone, and then tighter clothing for the healthier, fitter clone; a sort of hue in the makeup with the healthy clone, and a sickly aspect to the other clone as he got less and less well. I copied some stuff from Ratso Rizzo in *Midnight Cowboy* – the cough and that whole thing. My acting coach helped me with that."

BELOW: Preparing to shoot a scene in the clone room.

OPPOSITE TOP: Rockwell as Sam 1 and Chalk as Sam 2.

OPPOSITE BOTTOM: Chalk as Sam 1 in the clone room.

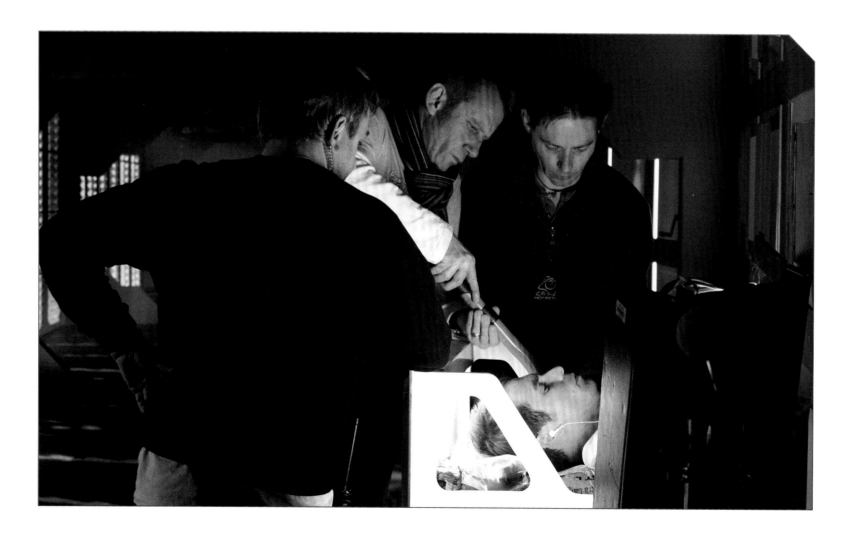

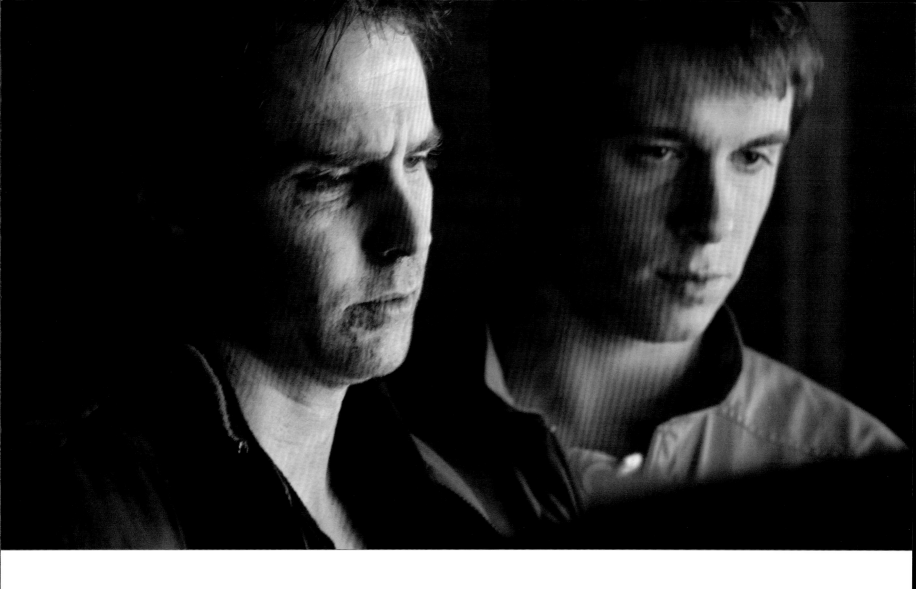

Through minutely planned camerawork, blocking, and two dedicated actors, the viewer has no choice but to suspend their disbelief and utterly invest in the story. The early reveal that Sam Bell is a clone is less a twist and more the first step on the journey these two men take, two men who, as Chalk puts it, "started out the same, but each one found a different way of dealing with the situation. Each and every Sam Bell was unique. I think that's a very powerful message. It's not about figuring out that they're clones, it's what they're going to do about it. You're still going to live whatever life you have to the best of your ability."

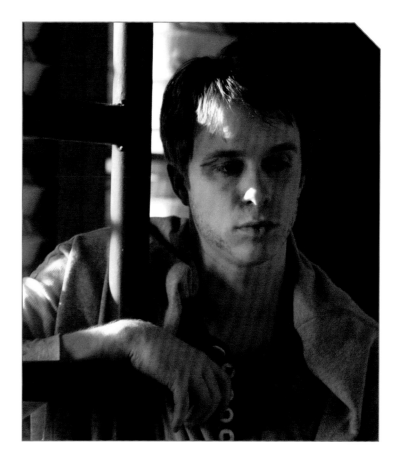

"SAM KNEW HOW IMPORTANT IT WAS TO GET IT RIGHT, SEEING AS IT WAS HIS MOVIE. IT WAS HIS STAR VEHICLE. FOR ME, HAVING PLANNED TO MAKE THIS MOVIE FOR SAM, I WANTED TO MAKE SURE THAT IT GOT THE VERY BEST OUT OF HIM."

DUNCAN JONES *DIRECTOR*

MOONBASE

THE SET

t some stage in making any independently funded film, the filmmakers reach a point when they have to commit and push forward, come hell or high water. Duncan Jones and Stuart Fenegan had reached that point months before. Now they had the script, they had backers who had committed to funding in principle, they had the lead actor, and the crew was waiting to begin work on the sets in earnest. Pausing just one element would jeopardize everything else. There was an extremely narrow window of opportunity before they would lose their actor.

Fenegan had set up a distribution deal with Sony Worldwide, but the deal had yet to close. Without that deal being closed they could not use the money in the EIS fund that was put by to build sets and pay people.

"Our company, Liberty Films, had cash-flowed the early stages of prep, and paid Nathan and started that early bit of preparation at Shepperton Studios," explains Fenegan. "Sam had now confirmed, and I was racing to get the Sony deal closed, which would pull everything together. Plus the freed-up EIS money allowed us to keep building and continue prepping. But it was all taking so long, because there are so many pieces of paper, so many legal documents, and so many people who need to review and approve everything. I felt I was getting one document done per night, staying up until 4am or 5am and then going into Shepperton to have breakfast with Duncan at 8am, and then napping on the sofa in my production office in the afternoon to try and stay alive.

BELOW: Sam 1 discovers the hidden panel to the clone room.

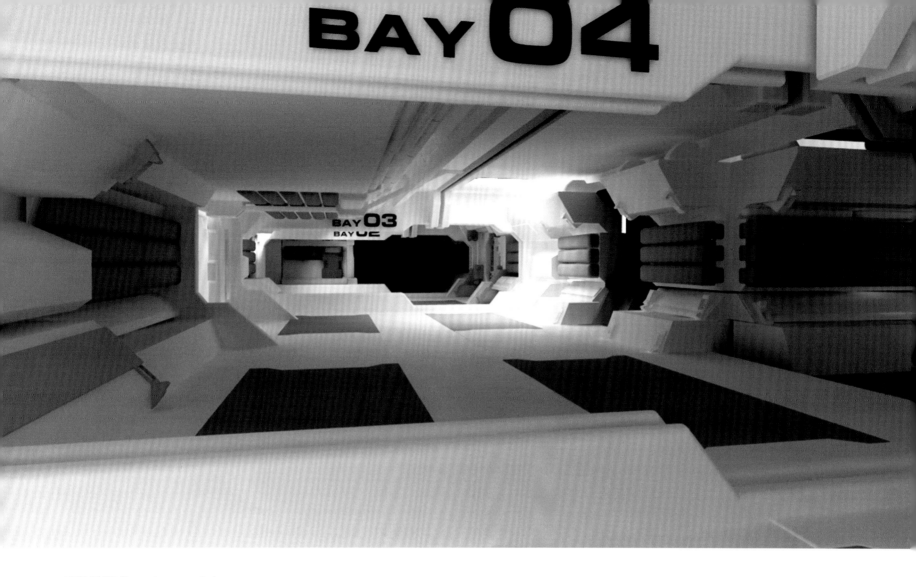

THIS PAGE: Computer generated
moonbase designs by Gavin Rothery.

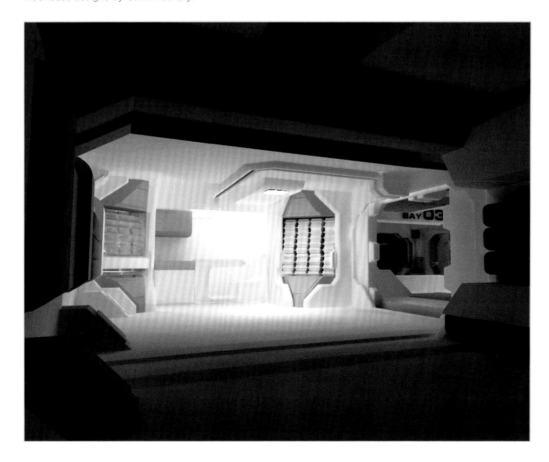

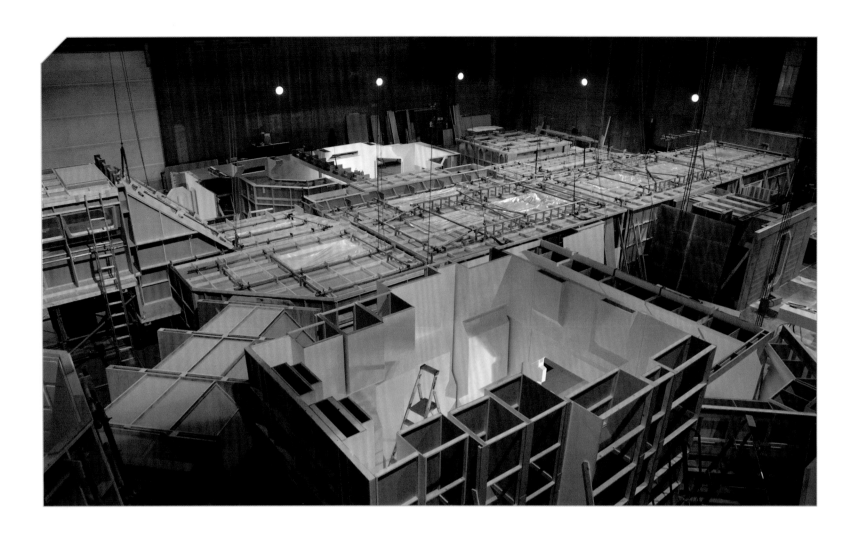

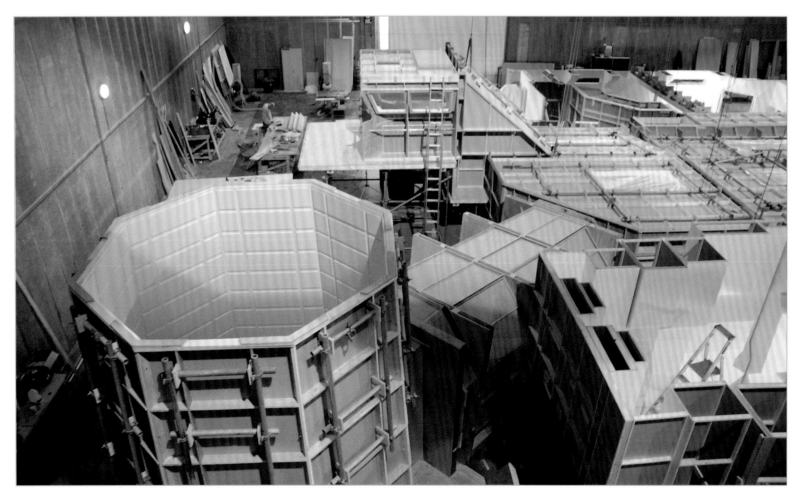

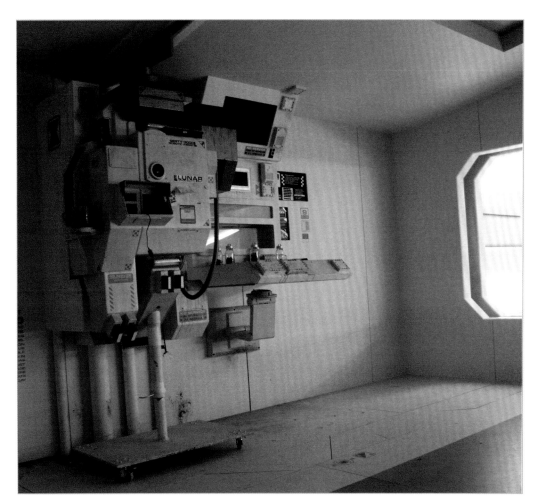

"The set was the second biggest line item in the budget," Fenegan continues "To build that was expensive and also, because it was so big, it took a long lead-time, so I spoke to the investors and said, 'Look, Duncan and I have spent all of our money and I need to push the button on set construction. That's going to require X amount of money and I haven't closed the Sony deal yet. I'm very confident that I'll close it within the next two weeks, but if we don't start building this week we'll miss our window with Sam, and Sam's availability means that if we don't start shooting on time we'll have to then drop days from the shoot schedule, which I don't want to do because it would hurt the movie. So what I'm asking is, with no guarantee whatsoever, will you let me start spending some of this EIS investment? And I need you to sign a document saying that you know that the film is not closed, there's no bond in place, and I cannot guarantee the return of that money.'"

It was one of the most anxious moments in the entire process. Either they could actually begin shooting their film or it would start to collapse, meaning they would have to begin again or walk away from the whole project. Like anxiously waiting in the dark of a lunar eclipse. Luckily, the light shone.

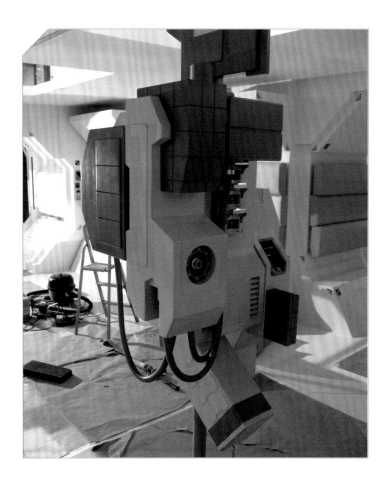

OPPOSITE: The moonbase set under construction.
ABOVE: Constructing the communications stations, one with the Gerty dock.
RIGHT: The pristine Gerty model on the under-construction moonbase set.

"THE INTERIOR SET COLOR IS OFF-WHITE. WHITE IS TOO MUCH, PURE WHITE IS TOO MUCH. ONE OF THE KEY THINGS WE LOOKED AT WAS *2001: A SPACE ODYSSEY* AND IF YOU LOOK AT THAT FILM, INSIDE THE HOTEL, THAT WAS A PEAT WHITE – JUST OFF WHITE. PURE WHITE BOUNCES LIGHT TOO MUCH AND YOU'RE FIGHTING IT ALL THE TIME."

TONY NOBLE *PRODUCTION DESIGNER*

"I got a text message back from Trevor Beattie, who's one of the investors and executives on the film and helped with some of the marketing. He had been a huge supporter of Duncan and me in our days in commercials. Duncan and I did the first ad for Trevor's own agency, BMB. Trevor sent me this amazing text message. Somewhere in my parent's loft I still have my old Nokia 8210, because I would never, ever get rid of it! There's a text message on there that says: 'Sir Stu! I gave you the money to spend, so spend it. Love, Trev'. I will never, ever, forget that, because that belief from Trevor that I'd get the Sony deal closed – which I did – and it would all be well, meant everything. Trudie Styler and the other EIS backers all agreed as well. It was that money that kept us going on schedule and gave me the time to close the distribution deal, and thus the full finance of the film. I will forever be grateful they did, and relieved it worked out!"

Work duly began on building the set.

The story and the film were designed in such a way as to get the maximum from as little as possible. As a result they hired a soundstage at Shepperton and filled the whole space with the moonbase set. It was built at a ratio of 1:1. No rooms were recycled as other rooms, no corridors were reversed to be tricked out as other locations – they had a set that conformed exactly to the geography of Sam Bell's home, and his prison.

Despite not coming from a sci-fi background, production designer Tony Noble had always liked the genre. That *Moon*'s set designs were based in a fictional world no one has experienced also conveniently meant, "No one can argue with you," Noble points out. The experience Noble brought to *Moon* gave the production the ability to work fast, economically, professionally, and with a great team of designers and construction workers alongside Noble.

BELOW: The observation deck in the moonbase set.

OPPOSITE: The medical bay in the moonbase set.

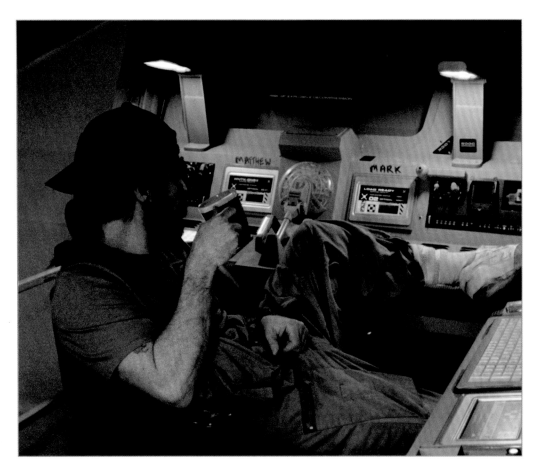

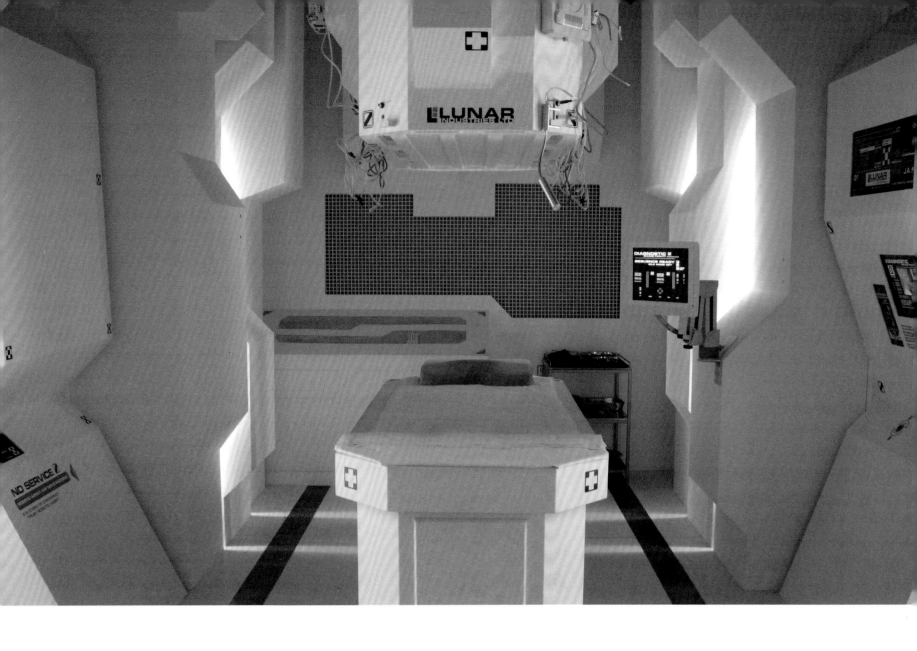

"I'd sit round the table with Duncan and sometimes Gavin and we'd just scribble ideas down on paper," explains Noble. "We took all of these scribbles and I then contacted my construction manager, Gene D'Cruze, who was my savior. There was so much stuff he put in, so many guys he brought in. We didn't have a lot of time or money, but Gene was great. Construction-wise we had fifteen to twenty guys. A lot of the stuff they built outside and shipped in. We ended up with a set and all the other elements that went with it. It was the main set with a center area with lots of rooms off of it – a comms room, Sam's sleeping quarters, the [plant] nursery – and it was just getting all the designs done, getting them drawn up onto paper and getting the guys to start building them. That was it."

Having worked separately with Jones, Fenegan, and Noble, Hideki Arichi was brought on as art director. Arichi was there for nine weeks of pre-production, liaising and supervising between the design department and construction team. Getting the geography, the actual footprint, of the set was integral for all departments, and conceptual designer Gavin Rothery had put in many hours of prep work to give everyone a head start.

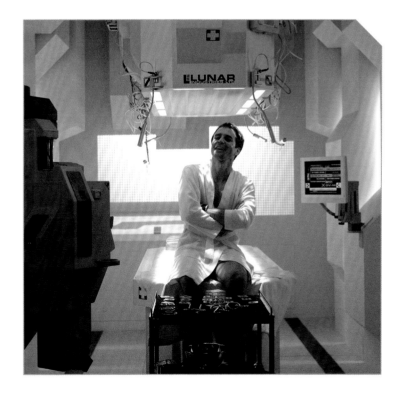

"We had a 3D walk-through computer-generated from Gavin, so the bare bones of it were there, more or less how the base itself would be set out," recalls Arichi. "The only thing we didn't have were actual dimensions or anything like that to go from... The bulkhead was the first thing that got constructed. We worked out how many we wanted, so when construction made one sample it was a very exciting moment for Duncan and Gavin to physically see the three-dimensional bulkhead. But even drawing that up, it went through quite a few different tweaks – eight feet here, or six feet or six feet six inches – before we could agree on the actual dimension, but everything sprang from that initial bulkhead, getting that right."

The set itself went to the very limits of the Shepperton soundstage, coming in at approximately eighty feet long. They built up to the farthest points; entering onto the soundstage was stepping into the set. Like Sam Bell, once you're in, you're staying in.

Having a set that anyone and everyone could walk around was useful not only as it helped make the experience as real as possible for an actor, but it also helps viewers immerse themselves in a world that feels authentic, tangible, and claustrophobic. As Jones puts it, "I've always been a fan of establishing geography and I always feel that is what marks good world-building. If you can move the camera around, certainly early on, to really give a sense of the geography and what the limitations are, that makes it real. Then you kind of feel like you're not just looking at a backdrop painting or a two-wall set; there is a location that this is all taking place in."

BELOW: Sam 2 at the bay 3 communications station.
OPPOSITE TOP LEFT: The clone room set.
OPPOSITE TOP RIGHT & BOTTOM: The bay 3 communications station.

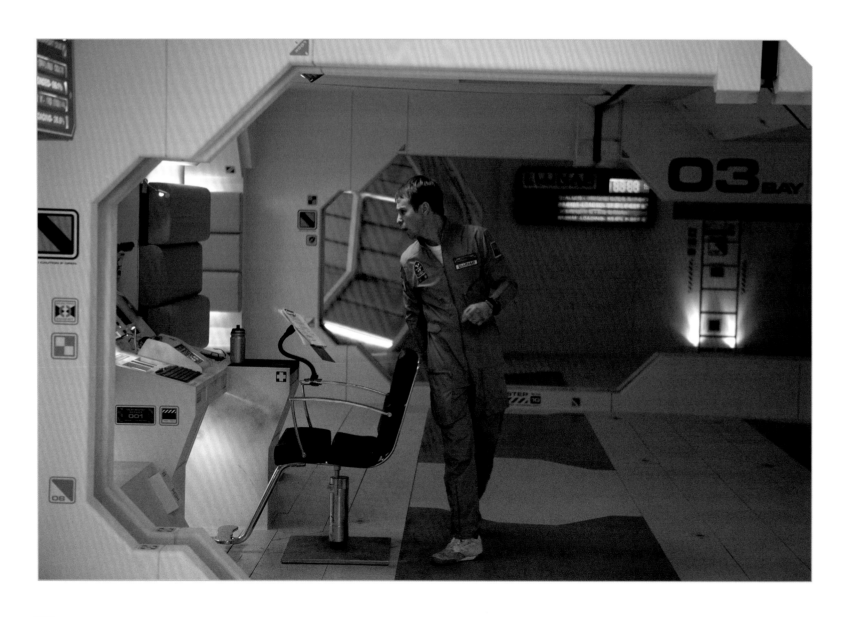

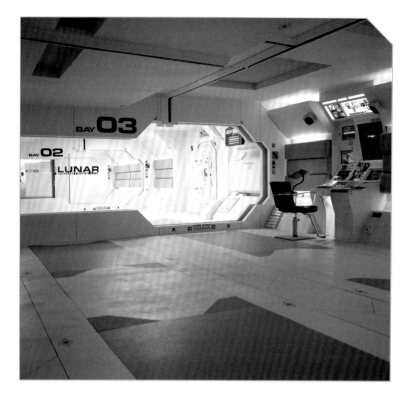

The set erected on all sides, with no wall, corridor or panel that wasn't designed with Sam Bell's fifteen-year occupancy in mind, afforded the camera crew some freedom in where they could frame a shot. There was no concern about seeing where the set ended and the real world might impose on their fiction.

For the purposes of economy and aesthetics, director of photography Gary Shaw took a novel approach to lighting.

"The station needed to feel lived in and we had initially toyed with the idea of interactive lighting as a futuristic 'energy saving' vibe, but we soon agreed that this would be too involved and, given our budget and schedule, too time-consuming and costly. It might also become irritating and distracting from the story itself... What we ended up doing was literally going to the wholesale electricity factories and buying loads of strip lights and gelling them all, so that we had some film lighting which we'd match with practical lighting. We rigged the whole place up like a giant house."

Noble confirms how much time this saved day-to-day on their hectic shooting schedule, with Shaw's thoughtful preparation minimizing the chances of unforeseen surprises. "You'd come in in the morning, turn the lights on and you were ready to shoot," he recalls. "Gary had the right kind of thinking and he lit it so that you could come in and start shooting directly, which I thought was inspired."

After nine weeks of preparation, they were ready to shoot. It was January 2008.

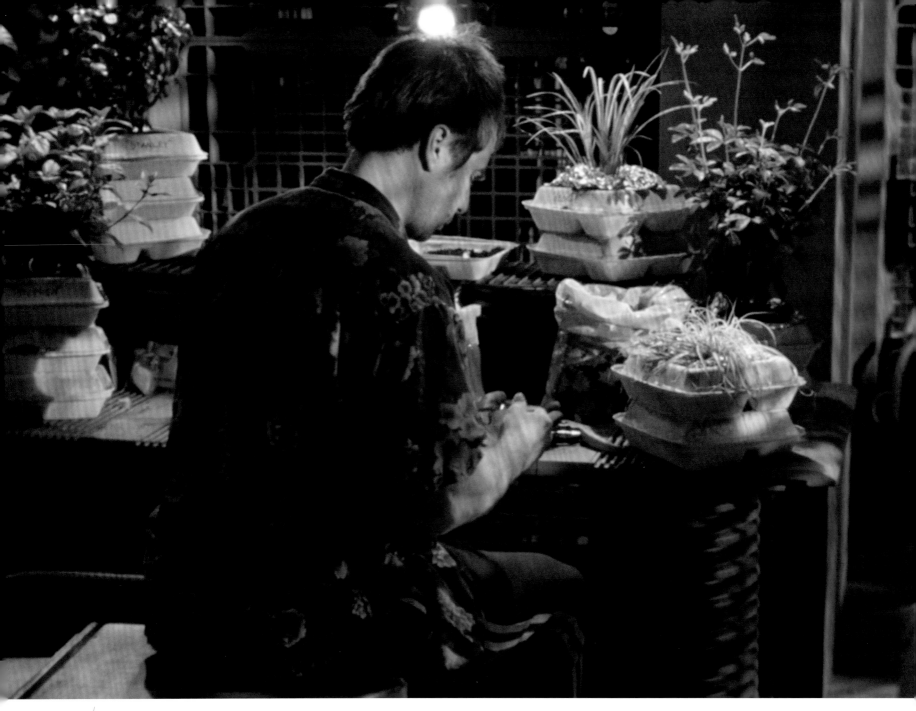

THIS PAGE: Sam 1 tends his plants, including Doug, Stephen, Stanley, Kathryn, George and Ridley.

OPPOSITE: A page from Jones's shooting script.

"THERE WAS AN AREA WHERE SAM WAS TENDING TO HIS PLANTS... THAT WAS ONE OF THOSE ROOMS WHERE WE NEVER REALLY GOT OUR HEADS AROUND IT. TONY NOBLE JUST CAME IN AND SAID, 'LOOK, WE DON'T HAVE MUCH MONEY LEFT, LET ME SEE IF I CAN PUT SOMETHING TOGETHER.' HE GOT A BUNCH OF OLD CRATES, PAINTED IT, PUT SOME BOARDS UP, PUT SOME STENCILS UP AND REALLY MADE SOMETHING OUT OF NOTHING. TONY REALLY CAME IN AND SAVED THE DAY."

DUNCAN JONES *DIRECTOR*

INT. SLEEPING QUARTERS -- MOMENTS LATER

handwritten: SL.361 SL.362

Sam 1 spills in. He RAPIDLY turns on the faucet and cups his hand to transfer water up to his face -- this going on for a few seconds.

handwritten: MS EVE

handwritten: TU WIDER 50 FPS

handwritten: CS SAM 1 (Fg)

MIRROR

handwritten: REFLECTED - FAV. EVE IN MIRROR (bg)

Sam 1 stares at his reflection in the mirror, holding a MOUND of TOILET PAPER against his NOSE. The blood flow has subsided

Suddenly Sam 1 sees the GIRL in the mirror. It gives him a hell of a FRIGHT.

The Girl remains in the mirror looking at Sam 1. A neutral expression, impassive. Sam 1 takes a deep breath, lowers the toilet paper from his nose.

 SAM 1
 Who are you?

No answer.

 SAM 1 (CONT'D)
 (shouting)
 Who are you!

handwritten: SC.510
handwritten: PAN EMPTY DOORWAY.
handwritten: SAM1'S ARM EDGE FRAME

handwritten: SC.511
handwritten: CS SAM1 REFLECTED IN MIRROR TURNS ARR. R/S AND SHOUTS.

handwritten: MOS

Liberty Films © 2007 - Version 2.8 Shooting Script 2 11th Dec 07
 BLUE REVISIONS 17/1/08 55.

handwritten: MS EVE

Sam 1 swings around to confront the Girl...but she's not there, she's vanished. Her reflection has vanished from the mirror also.

SHOOT FOR THE MOON

THE SHOOT

SHOOT FOR THE MOON
THE SHOOT

ometimes luck has a part to play. All the planning and best intentions in the world may only take you so far, with unforeseen circumstances getting you over the finish line.

From November 2007 until February 2008, the Writers Guild of America (WGA) went on strike, effectively shutting down work on film and TV production. Many movies were postponed or cancelled outright. But Hollywood's loss was *Moon*'s gain. Duncan Jones was not yet part of the WGA, so work could continue apace, and this small independent British film found itself as the only show in town.

"I remember vividly early on when we would go into the cafeteria – it was always packed – and people would ask, 'What are you working on?' and we would say, '*Moon*, on K stage,' and they would say, 'Never heard of it.' And then cut to a few weeks later: everyone had closed down. All of a sudden, there was all this amazing crew that weren't working," recalls Stuart Fenegan. "So *The Wolf Man*,

the Ridley Scott *Robin Hood* movie – which, at the time, was called *Nottingham* – and the Working Title film *Pirate Radio/The Boat That Rocked*, they all stopped production... I spoke to [visual effects house] Cinesite and asked who the best model miniatures DP [director of photography] was and they said that all the work they had been doing on the *Harry Potter* franchise, all of those miniatures, had been shot by Peter Talbot. I called him up and said that I knew he was booked to do the miniatures on *Robin Hood*, but now that that's not going, would he take a look at *Moon* and be interested in shooting our miniatures? He said, 'Sure.' And it was the same with Bill Pearson, the model miniatures genius who had his workshop based at Shepperton Studios. It was a really tough time, because lots of things weren't shooting miniatures, and he'd done all these miniatures for *Robin Hood* and I remember hearing that they'd shot them but decided to do them in CG rather than using the miniatures that they'd already shot."

BELOW LEFT: The entrance to Shepperton Studios' K stage.

BELOW MIDDLE: Director of photography Gary Shaw.

BELOW RIGHT: Gaffer Ewan Cassidy testing Sam Bell's chair. "Duncan is quite 'hands-off,' but he had some specific props and items that he did want to include within certain sets and spaces, and elements that he wanted incorporated into the design somewhere," says art director Hideki Arichi. "The brown leather chair in the recreation room is a reference from a seat that was in The Two Brewers pub near the film school we met at."

OPPOSITE: Duncan Jones on the under-construction Tess's apartment set.

NEXT SPREAD: Rockwell, Dominique McElligott and Jones shooting a Sam Bell dream/memory scene on the Tess's apartment set.

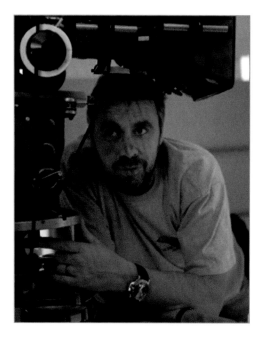

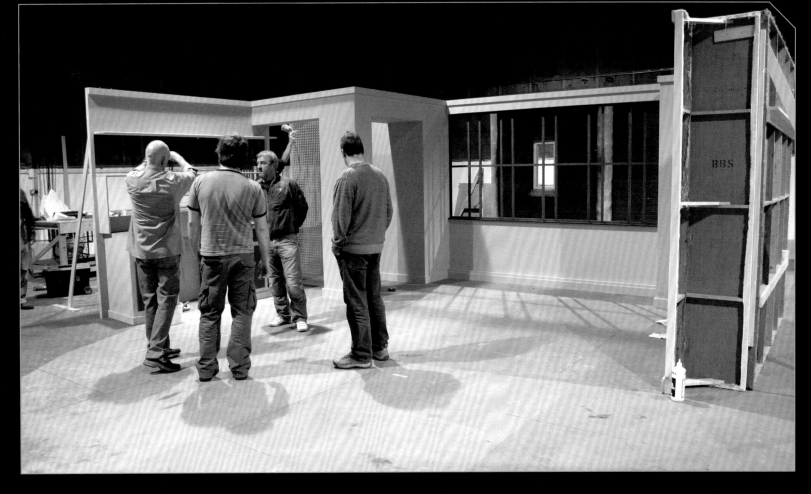

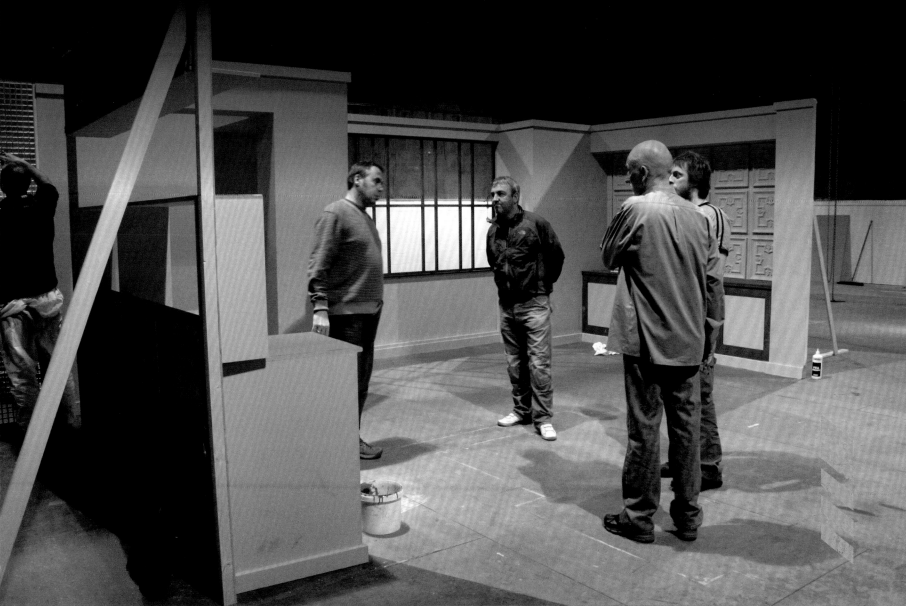

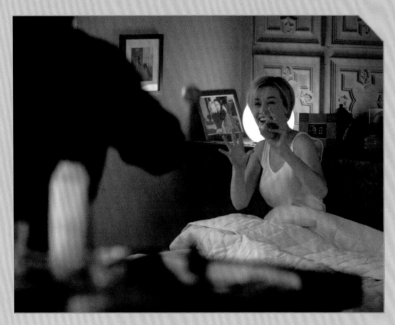

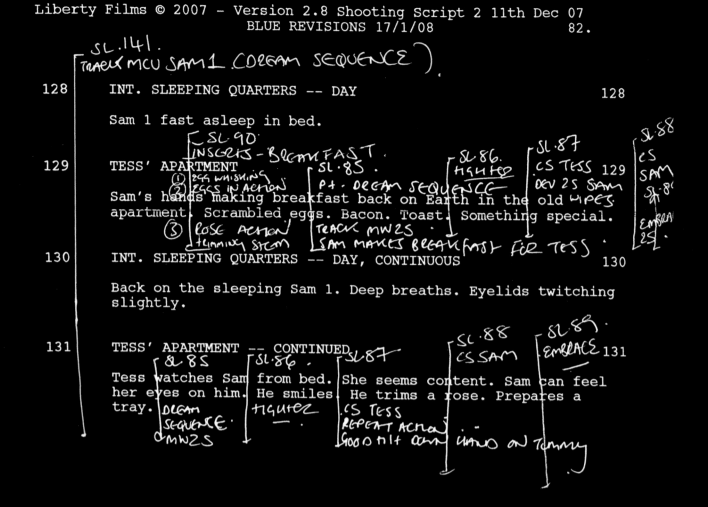

SL.141.
TRACK MCU SAM1 (DREAM SEQUENCE).

128 INT. SLEEPING QUARTERS -- DAY 128

Sam 1 fast asleep in bed.

SL.90
INSERTS - BREAKFAST.
129 TESS' APARTMENT 129
 ① EGG WHISKING SL.85 SL.86 SL.87 SL.88
 ② EGGS IN ACTION HIGH FED CS TESS CS
Sam's hands making breakfast back on Earth in the old SAM
 P.V. DREAM SEQUENCE DEV 2S SAM WIPES SL.89
apartment. Scrambled eggs. Bacon. Toast. Something special.
 ③ ROSE ACTION TRACK MW2S EMBRA
 + trimming stem SAM MAKES BREAKFAST FOR TESS 2S.

130 INT. SLEEPING QUARTERS -- DAY, CONTINUOUS 130

Back on the sleeping Sam 1. Deep breaths. Eyelids twitching
slightly.

131 TESS' APARTMENT -- CONTINUED 131
 & 8S SL.86 SL.87 SL.88 SL.89.
 CS SAM EMBRACE
Tess watches Sam from bed. She seems content. Sam can feel
her eyes on him. He smiles. He trims a rose. Prepares a
tray. DREAM figure CS TESS
 SEQUENCE. REPEAT ACTION
 MW2S GOOD tilt down hands on Tommy

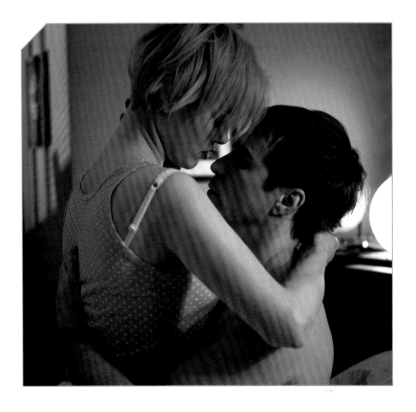

It was not just an abundance of available talent that blessed the production, there were also purely financial benefits. "I think we saved about £1,500, which I know doesn't sound a lot, but my budget was so tight and I was fighting for every pound," Fenegan explains. "I saved about £1,500 on stationery, because when *Robin Hood* went down they'd already stocked their stationery cupboard. Because their writer wasn't able to carry on writing and the studio paused pre-production on *Robin Hood*, we inherited all their stationery – paper, folders, pens, Post-It notes. My production manager went over there with a trolley and picked it all up and brought it back, and we were all high-fiving one another because we'd just saved a load of money on stationery."

> **"ORIGINALLY WE WERE ON ONE STAGE, BUT AS THE FILM EVOLVED IT BECAME OBVIOUS WE COULDN'T DO EVERYTHING THERE."**
>
> **TONY NOBLE *PRODUCTION DESIGNER***

A good producer, a good low-budget producer, knows how to take advantage of an opportunity. A motto that could apply to the film (or even a multinational evil corporation with a whole army of clones at its disposal) is surely waste not, want not... "Suddenly Shepperton had loads of studio space available," continues Fenegan. "So I remember sitting down with my line producer Julia Valentine and production manager Imogen Bell, and asking if it would be cheaper and easier for us if we had more space. They said it would definitely be easier, because they could build Sam's house exterior set and the rover cab on the gimbal on separate stages rather than have

to squeeze a corner of our K stage, because basically the moonbase filled it. So I went and spoke to an amazing guy at Shepperton Studios, [sales director] Noel Tovey, and asked him if there was any chance I could get more stages and/or a workshop for these other sets, and Noel said that that would be brilliant. Then I told him that I needed them for free, because I didn't have the money for them, and they were going to be sitting there empty anyway because of the writers' strike, so it was better that I owed him a favor and he helped the production than the stage space go to waste. I remember Noel smiling at me and saying that he would see what he could do."

OPPOSITE TOP: A section from Jones's shooting script.

OPPOSITE BOTTOM: Shooting another dream/memory sequence.

BELOW: McElligott, Jones and Rosie Shaw shooting video message scenes on the Bell family home set.

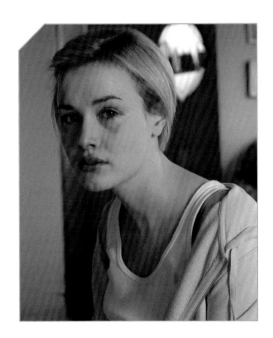

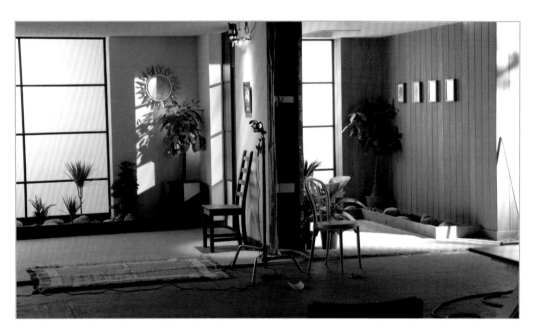

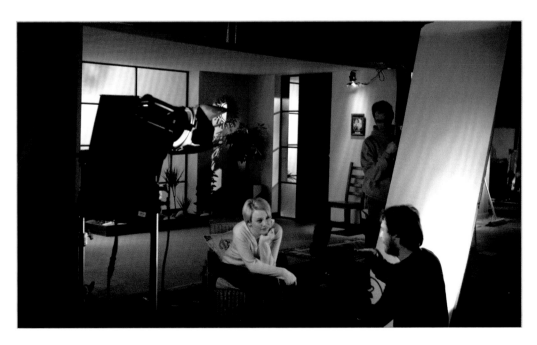

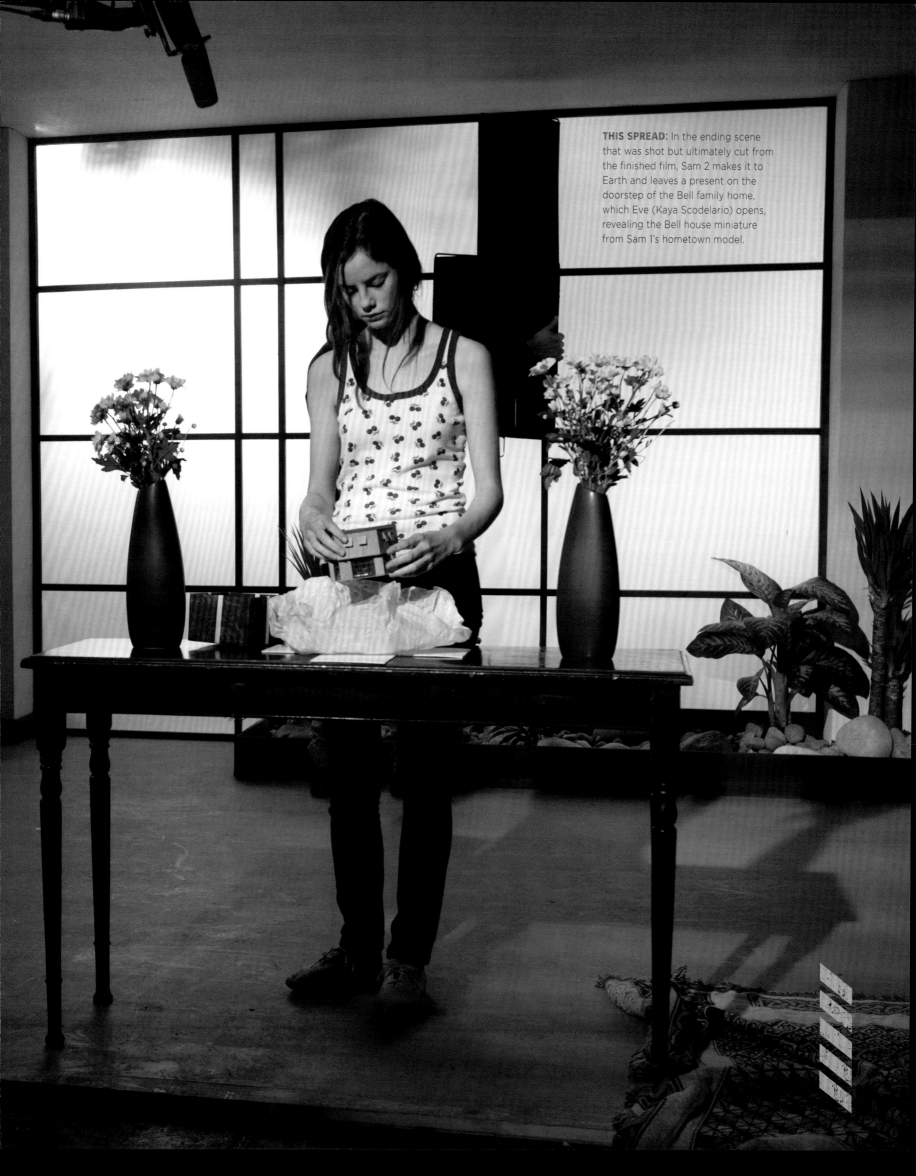

THIS SPREAD: In the ending scene that was shot but ultimately cut from the finished film, Sam 2 makes it to Earth and leaves a present on the doorstep of the Bell family home, which Eve (Kaya Scodelario) opens, revealing the Bell house miniature from Sam 1's hometown model.

They got their stage space, enabling them to shoot the above-mentioned elements, but also Sam's apartment and the boardroom scenes as seen on the comms screen. That extra space meant they could build the sets more fully, instead of shooting them as a compromised extension of their main K stage, and more people could work simultaneously. One of the key memories from everyone on set was that it was about getting the work done as well and quickly as possible each day. No time to lose. To quote director of photography Gary Shaw, the shoot was "thirty-three days and a pick-up day on main unit, then a week for the miniatures... You've got to get it done on budget, and on time. There's nothing wrong with that. Movement of the camera and lighting, it's part of the story, but in that way we were slightly forced into a corner. The film was just on budget, so we really had no choice but to get it done by any means. Improvise. We got those little 'pop out' lights from B&Q, tiny camping lights and LEDs you put inside wardrobes. There's a bit where Sam hauls all those casks out and at the end of each of those there's a tiny little camping light, literally just a camping light you'd get from B&Q with a bit of gel stuck to it, and that's it. It was as run-and-gun and mercenary as that in places."

Moon had hoped to emulate such classic, grounded sci-fi movies as *Alien*, and this carried through into the set dressing, with cheap, unremarkable items being put to

BELOW: Benedict Wong, Matt Berry and Jones shooting the Thompson and Overmeyers scenes on the Lunar Industries boardroom set.

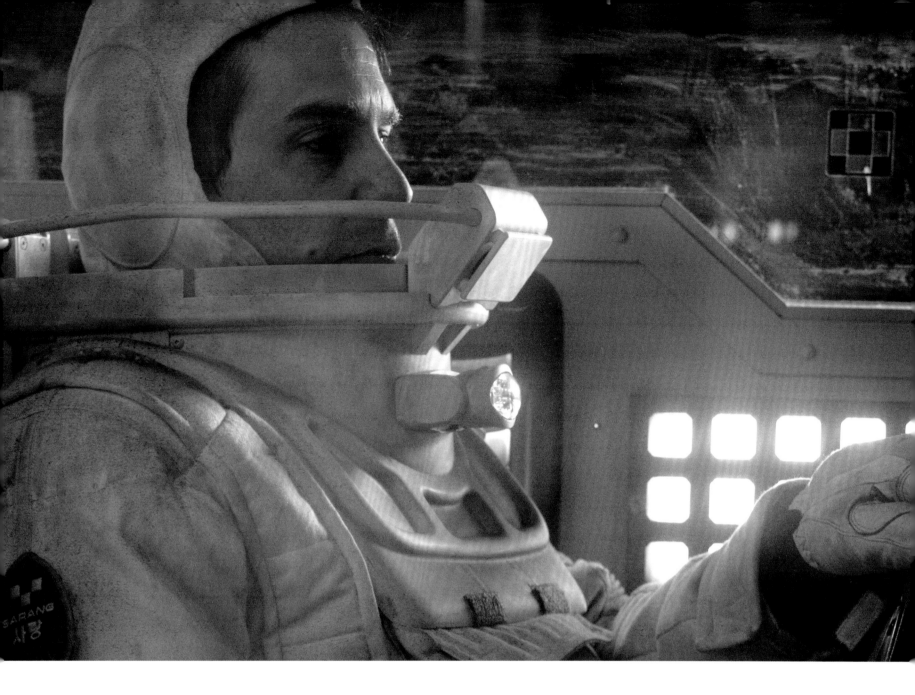

good use.

"Cutlery trays. Things like old pipes, bits of plastic. If you do it in the right way, you can't tell," production designer Tony Noble confides. "There's one scene where Sam's in the rover, looking outside, and the thing about sci-fi is you can't really have flat surfaces. It's got to be full of stuff. And we had this area round the window and I went to Wilko's and I found a plastic mousetrap made of bits. I bought about half a dozen and they're all round the window, painted the same color. No one knows. I won't tell if you don't."

Like some sort of 'bring your own' party, everyone ended up contributing something to the common fund.

"In Sam's rec room, Duncan was specific about the food cartons. That was something Gavin and Duncan were eating from in a Mexican restaurant in Soho," art director Hideki Arichi reveals. "They liked the containers, so we sourced all those containers and built the storage units for them, from those pre-existing containers."

For the moon's surface, senior model maker John Lee says, "Steve Howarth and myself drove down to the local quarry in Shepperton and filled his car up with small-to-giant concrete rocks, which were very similar to the large boulders you see on the moon. Once those were covered with powders and finer grains, it all looked quite real."

ABOVE: Final shot of Sam 1 driving a rover.

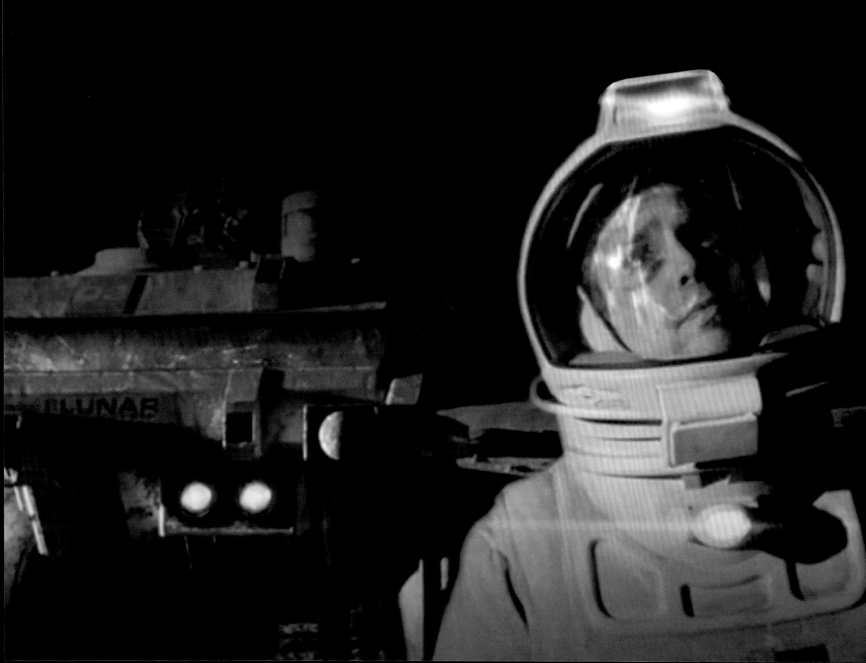

"There's a set of gloves that Sam wears, they're still in my garage – they were *my* gardening gloves in the first place!" director of photography Gary Shaw says. "Not that I do much gardening, but they were in the car and I showed them to Sam and he said they looked kind of industrial, kind of real – they don't look very space age. I said, 'What do you want to do, do a *Doctor Who* and spray them silver?' And he said, 'No, let's have them real.'"

Similarly, costume designer Jane Petrie recalls that "The 'Wake Me When It's Quitting Time' piece is Sam Rockwell's own T-shirt, as are the slippers, tracksuit bottoms, and Hawaiian shirt."

The costumes heavily inform the Sam Bell characters, giving an insight into their personalities and what stage (they think) they are in their lives. Sam 2 wears his grey flight suit zipped up – he is trim, functional, economical, taking himself and his job seriously. Whereas Sam 1, the older model, is far more chilled out, and also beginning his decline. On him the same flight suit was, Petrie estimates, "probably a size-and-a-half bigger. His is tired and worn and baggy, to make him look like he's shrinking a bit."

OPPOSITE: Shot elements (top) and final shots of Sam 1 and a rover on the lunar surface.

BELOW: Sam Rockwell and Robin Chalk on the moonbase set.

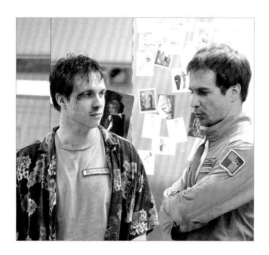

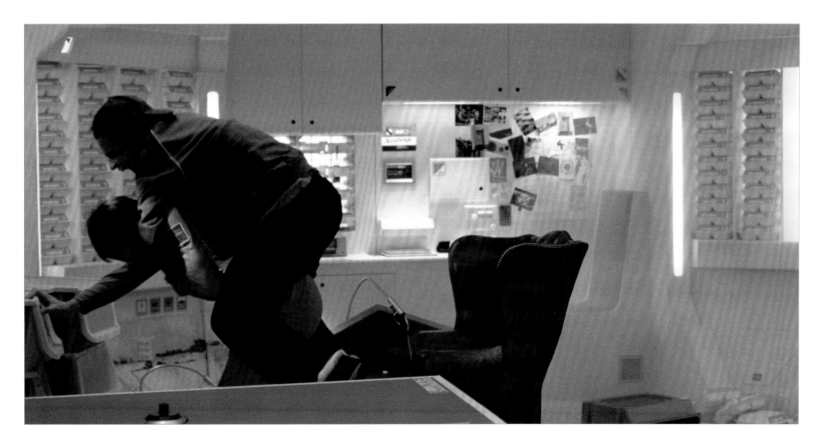

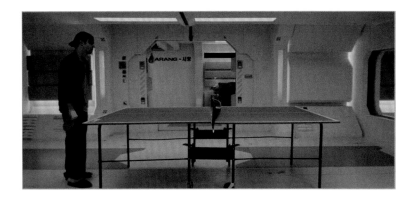
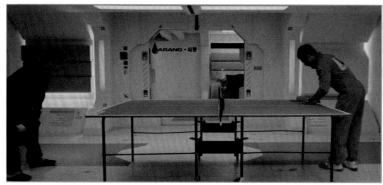
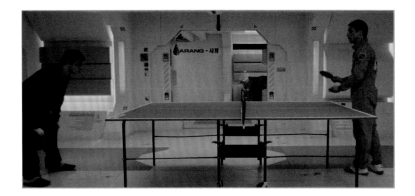
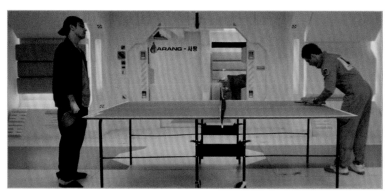

To be able to carry off the looks for both clones, Sam Rockwell had to be very careful to keep his physical appearance consistent throughout the shoot. "I was trying to stay at a certain kind of body type. I was very disciplined. I was going to the gym all the time. I was trying to look thin to be sick *and* look healthy to be the healthy clone. I was very monk-like. Fortunately we shot it in such a short amount of time that I never, thank god, had to hit the wine! I lived quite 'monkly.' I was living in this hotel and going to work. I was smoking rolly cigarettes with licorice paper, drinking coffee. Mentally it was very taxing. I had to be really clear-minded."

Sam Bell's emotional state and journey is told through his appearance, something Rockwell and Petrie focused in on. "Everyone assumed we were referencing Harry Dean Stanton in his Hawaiian shirt in *Alien*, and that's not true. We were referencing another film. Sam Rockwell had said to me, 'I am comparing the two Sams – the one straight out of the wrapper, and the older, failing model. It's *Midnight Cowboy*. It's Joe Buck and Ratso.' That's the sort of character note Sam gave me. 'That's where I'm at with who they are, these two men.' Him at the end in a Hawaiian shirt, that's Ratso on the bus to Florida, dying, that's not Harry Dean Stanton in *Alien*. Though, if you believe it, it doesn't matter if it's Harry Dean Stanton or Ratso, you just have to buy into it and believe in the journey of this character."

"*Midnight Cowboy* is about a relationship. It's a buddy movie," says Sam Rockwell, explaining why he chose to reference that particular film. "*Moon* is a buddy movie. In addition to being other things. *Dead Ringers* was very helpful. I also watched *Multiplicity* with Michael Keaton in – that was useful. There was a movie at the time with Will Smith called *I Am Legend*, where he is alone on planet

Earth and I found that movie very helpful, too. There's always a bit of *Taxi Driver* in everything I do. There's a kind of lonely thing to these characters.

"Of course we stole from *Alien* and *Silent Running*," Rockwell adds. "I remember watching *2001*, *Blade Runner*, and all these great movies and really wanting to pay homage to them. We really wanted to do that realistic sci-fi. We wanted that tone. The juxtaposition of kitchen sink drama on a space station is really cool, I think."

There wasn't the budget for multiple sets of duplicate clothes for Sam, so Petrie and her assistant, Lucy Donowho, were constantly repairing and readying costumes, as well as keeping track for continuity.

"We could only work with each Sam [actor, Rockwell and Robin Chalk,] having his 'fresh out the packet,' 'character in decline,' and 'bloody' iterations," explains Petrie. "That was the amount of stuff we had. We never had eight of these and eight of those, which is your usual starting point. We had to be creative. We would apply the blood on set, but couldn't have a replacement lined up and ready for him to swap in a clean one. We'd often be cleaning things, and moving things back and forward if it was needed."

The clothes that seem so much a part of Sam's personality are, in the story, one of the details that show how utterly manipulative Lunar Industries are. When the Sams discover the clone room, each clone has its own pack of belongings, including their mass-produced-idiosyncratic outfit.

OPPOSITE TOP: Shooting Sam 1 and Sam 2 playing table tennis and a final still from the scene (bottom right).

OPPOSITE BOTTOM: Sam 2.

ABOVE: Rockwell as one of the previous Sam Bell clones, with Jones.

"They're his personal things and they're not personal," Petrie agrees. "There's hundreds of them... I had a big problem with it initially before we figured that out; it was a big hurdle that I couldn't deal with. I went to speak to Duncan about it, and I said, 'Look, if he's wearing all of these clothes, how does that work? Because when his time runs out and another clone wakes up, these clothes are going to be knackered. They're not going to be there by ten generations on. How can you justify personal clothing four generations, six generations on? I don't believe it!' Then I said, 'Unless you're saying that the company are cynical enough to have also made and created duplicates of everything that the first Sam took up with him in his suitcase...' And Duncan said, 'Yes, that's the logic that will work, but how are we going to show it? How can we do it?' The only opportunity was when they discover all the clones in the tunnel, and

he pulls a drawer out. The plastic see-through pillow that the clone's lying on, underneath is a pack and you can clearly see the slippers, and the 'Wake Me When It's Quitting Time' T-shirt. You can see that it's all there."

The degradation of Sam extended to not only his clothes, but the set as well. In keeping with the realistic, aged world that Bell embodies, the crew decided to apply the same logic to the moonbase living quarters.

"There was a whole process of decision-making about ageing," confirms Jones. "You've already got a film crew stomping around the set all day on these big pristine white and black floors – what are we going to do about it? What we decided was, we'll let it look used. As long as you can't see big boot-prints everywhere, it should look like natural wear and tear. It's a bit dirty. After all, he's on his own, with no one there to nag him! Other than Gerty."

BELOW: Sam 2 and Sam 1 by the hatch to the clone room.

OPPOSITE: The clone room set. "Where they find the chamber underground, Duncan, Hideki and myself had a great deal of deliberation about that," says production designer Tony Noble. "My take was, to make this work there have to be hundreds of clones, but they said, 'We've only got a small stage.' So we took another stage on. They didn't want to do it with CGI. I said, 'Let's try doing it as a perspective set.' I asked Hideki to build a white model, and they did. That set is only 15-foot deep and it looks like it goes on forever."

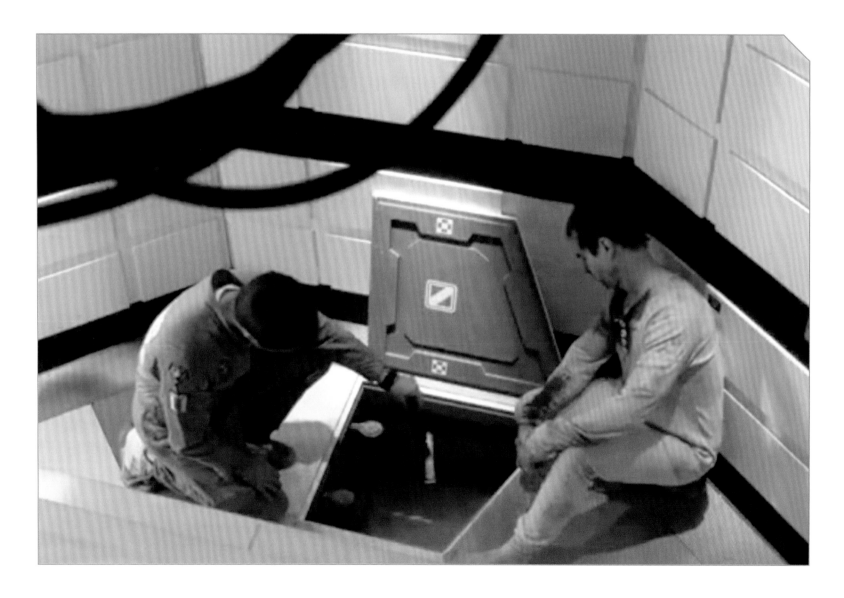

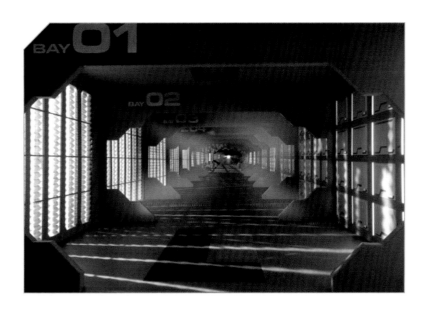

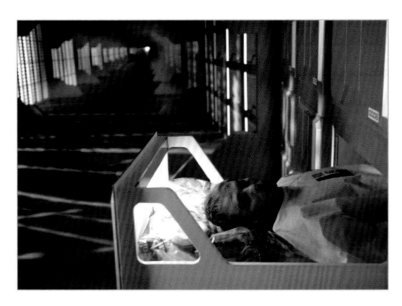
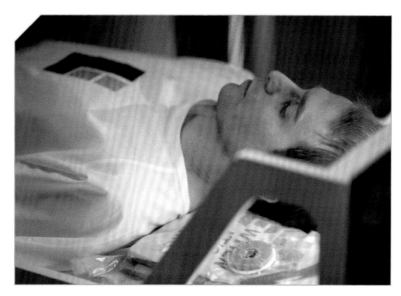
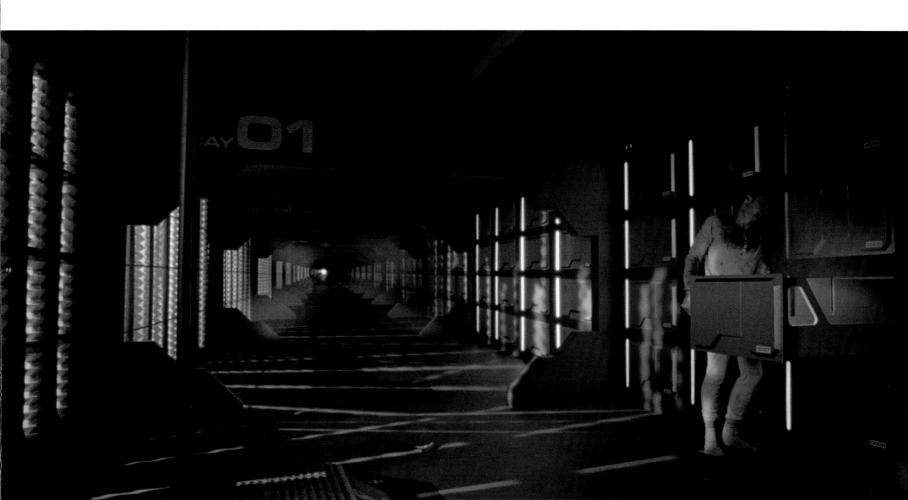

They spent thirty-three days over six weeks shooting, with long hours, non-stop planning and executing, improvisations, and quick fixes, and a few hours sleep at the end of each day. But it all worked. No one stormed off, no one had to be replaced. Everyone pulled together, did what they could, and the shoot wrapped on schedule. They had the makings of a movie.

"It was a really really challenging time," remembers Fenegan. "Duncan and I were both ridiculously excited and stressed all the time for the entire period. And my wife was pregnant all the way through production with our twins, Campbell and Vienna, who were born two weeks after we wrapped.

"I remember that when Elena came to visit the set for the last time, the unit nurse followed her around and wouldn't be more than about ten feet from her at any moment," Fenegan adds. "She was eight months pregnant and huge with the twins, and the unit nurse was convinced she was going to go into labor at any moment. I was joking to Duncan and Elena and Sam at the monitors about how happy I would be if Elena did go into labor on the set, because then, in later life, my kids could say they were born on a moonbase. Then if someone responded, 'No, you weren't,' they could whip out a photograph of them being born in the rec room of the moonbase, with Sam Rockwell in a spacesuit in the background."

BELOW: Rockwell as Sam 2 in his clean spacesuit.

OPPOSITE: Sam 2 with one of Gerty's arms.

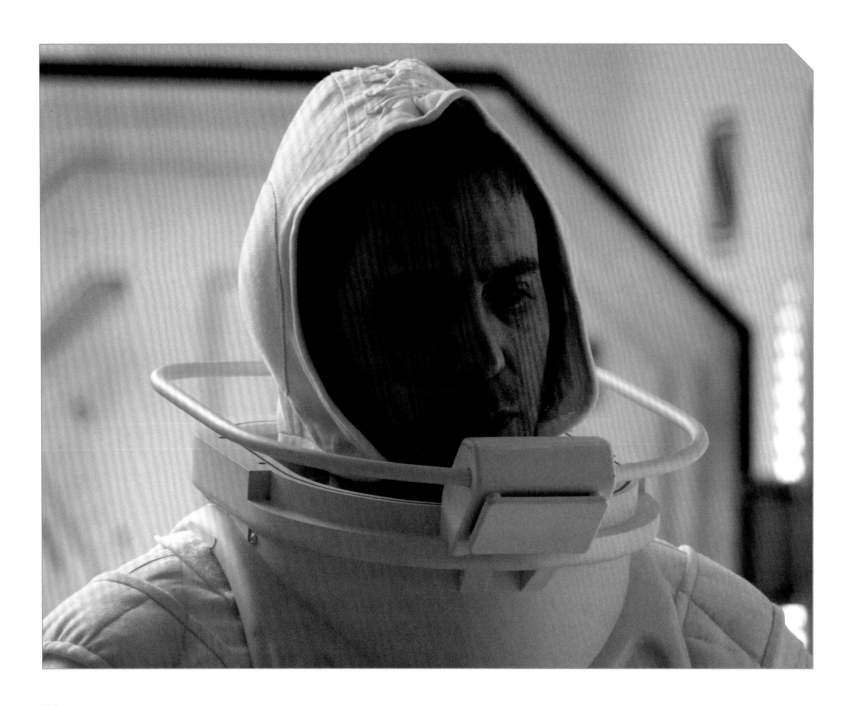

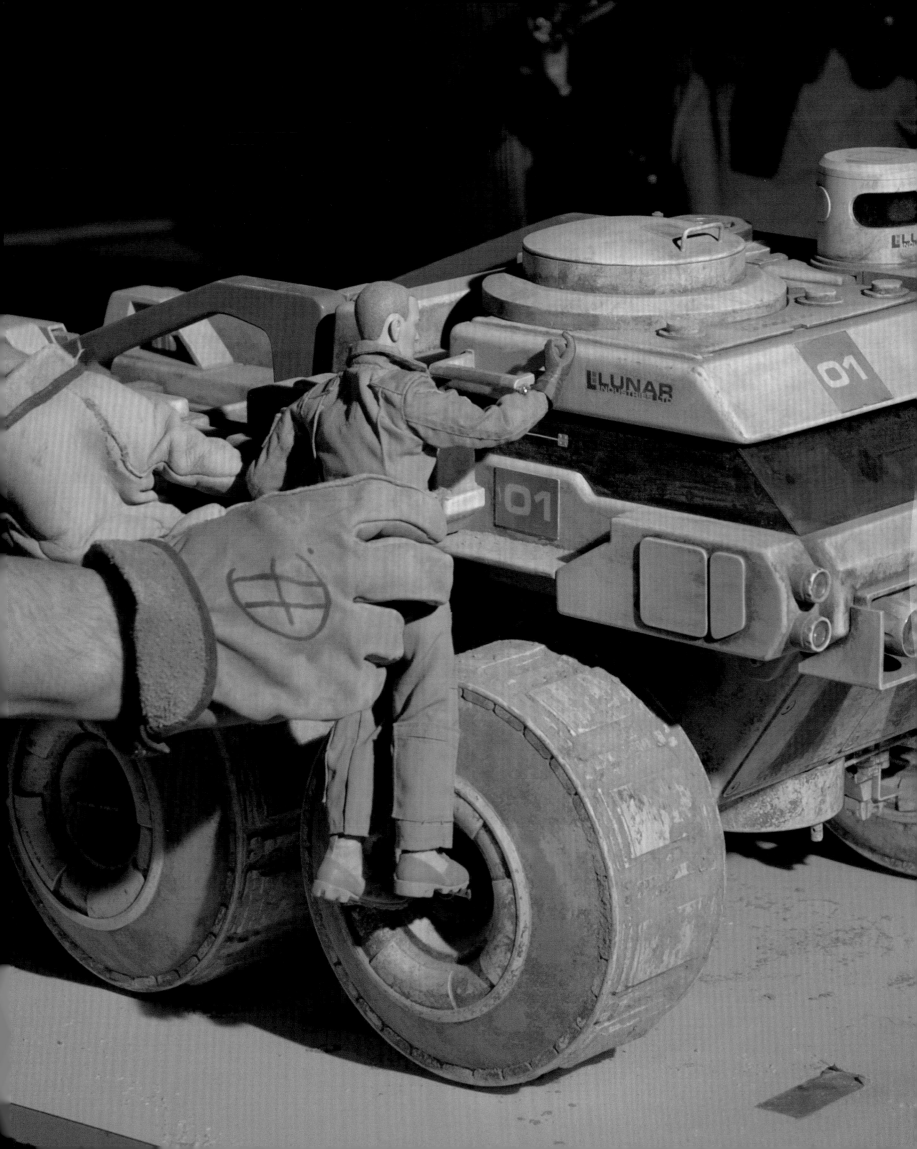

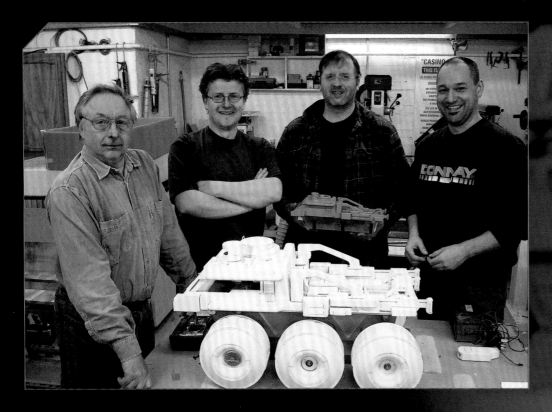

Duncan Jones has a keen interest in new technology, and his research greatly informed *Moon*'s near-future realistic setting. The narrative decision to have Sam Bell stationed on the moon in order to mine Helium 3 for Lunar Industries was inspired by extrapolating existing theories.

"That came from the Robert Zubrin book *Entering Space*," confirms Jones. "He's worked with NASA and he wrote this book about twenty years ago [it was first published in 1999], postulating what would be the fiscal benefits of doing any industry on the moon. What he came up with assumes, rightly, that Helium 3 is a very effective fuel for fusion power reactors. Very difficult and rare to get here on Earth but, bizarrely – as is explained in *Moon* – because of the moon's surface essentially being a sponge to harbor Helium

3 as it's thrown out by the sun, you get inches of this stuff basically penetrating and sitting in the lunar regolith [a layer of loose deposits covering a planetary body's bedrock]. If you could scoop all of that up with a harvesting machine and cook it to release the gasses, you could collect Helium 3 in pretty vast quantities, condense it, liquefy it, put it in capsules, send it back to Earth, and it would pay for itself handsomely. That was kind of the reason for it and the science behind it. Obviously, I'm very happy to say that, with the progress of solar and electrification, hopefully those things are less necessary. We may actually be able to generate our own energy just using off-shore wind and wave power and geothermal and solar panels. But that was the big idea when Robert Zubrin wrote his book."

LEFT: Special effects model makers Ron Hone, John Lee, Steve Howarth and Chris Hayes with the two scales of rovers for comparison.

THIS IMAGE: Close-up of Sarang Base control tower, with escape vehicle in foreground.

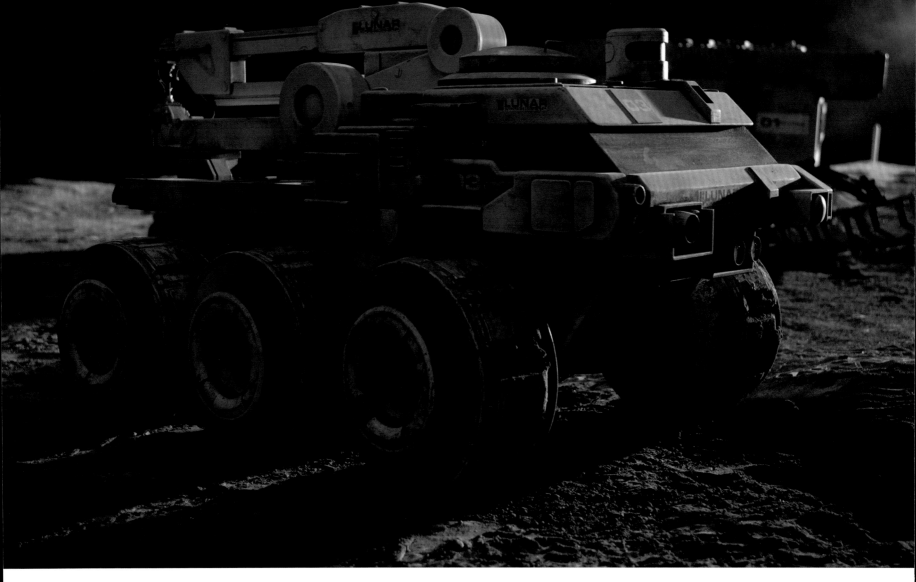

ABOVE: Traditional forced-perspective shot being set up with 1:6 scale rover 3, in foreground, with the 1:12 scale harvester beyond.

Making this the reason for putting a person on the moon makes story sense, but knowing the value of Helium 3 also explains why Lunar Industries would go so far as to clone someone. The product is more important than the clones. For a film that is much more about the personal and the interior life, there is a statement here about big business and individual worth.

To convincingly show the working life of Sam Bell and to give some scale to the film – to take aesthetic advantage of being set on the moon – the story ventures outside the confines of the base and shows Sam branching out in his rover, as well as the Zubrin-inspired harvesters cruising over the satellite's surface. It almost goes without saying that achieving atmospheric shots of great machines caravanning across the lunar body would require digital effects. But the filmmakers decided to go in a different direction, one more in line with the practical effects work of the vintage sci-fi films they admired.

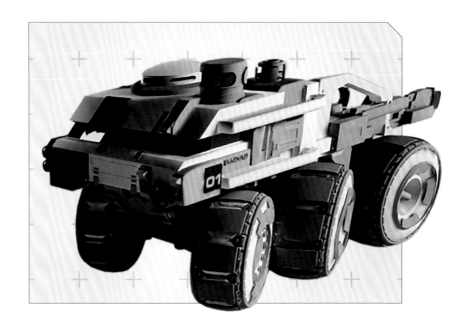

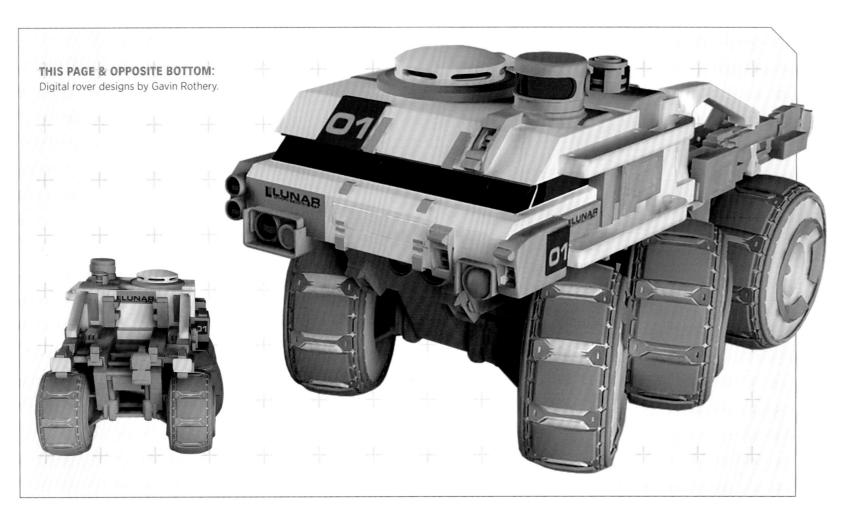

THIS PAGE & OPPOSITE BOTTOM:
Digital rover designs by Gavin Rothery.

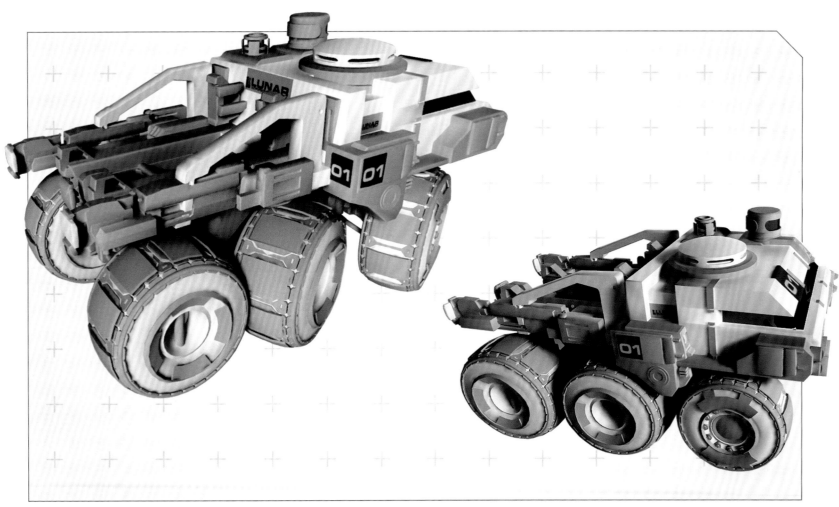

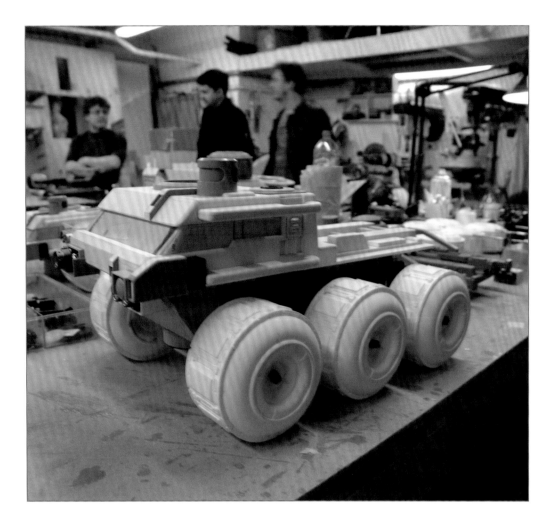

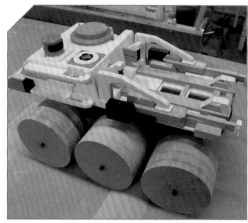

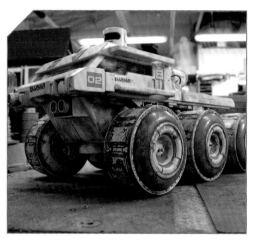

"Gavin was a big fan of model miniatures," says Jones. "He had shown me things that meant a lot to him as far as model effects work, we discussed it with other people who had some experience with it, and we decided that if we could make miniatures work, that would be the way to go. Also, it was ten years ago and effects were more expensive and in some ways not as good. So I think our miniatures really held their own at a time when to get really good visual effects would have cost a lot more."

Once it had been decided that miniatures was the way to go, Stuart Fenegan and Jones searched for the best available miniatures artists. Model work was going out of fashion and it was – and is – becoming harder to find those with the experience. Fortunately they found one of the best in the business a few corridors away at Shepperton.

Bill Pearson is an industry legend when it comes to in-camera model work. His filmography includes *Alien* (which won an Oscar for visual effects), *Flash Gordon*, *Outland*, *Casino Royale*, *Gravity*, and many more. He is a giant of the miniatures world.

"Bill was talking about retiring and closing down his workshop," recalls Fenegan. "Duncan, Gavin and I had been talking about different ways to do the rovers and the harvesters. We'd been talking with the effects house Cinesite and we had done all sorts of budgets and breakdowns about full CG versus part CG; we'd thought about doing remote-controlled axles with tyres on a lunar landscape, and then CG-ing the chassis onto that. Then we wanted to look at full miniatures, because Duncan loves the miniatures in those classic sci-fis that we'd referenced. So we went and spoke to Bill, and he said that he was going to close, but he asked to read the script. He read it, thought it was amazing, and said, 'Let's do it.'"

TOP LEFT: Stuart Fenegan and Duncan Jones on an early visit to Bill Pearson's workshop. Small rover under construction in foreground.

TOP RIGHT: 1:12 scale rover 1 takes shape. The suspension was tested with simple MDF block wheels before fitting the fully detailed versions.

OPPOSITE TOP LEFT: Moonbase rover garage, built by Pearson at 1:12 scale.

OPPOSITE TOP RIGHT: Senior model maker John Lee setting up the large 1:6 scale rover 3 to camera, ready for a close-up.

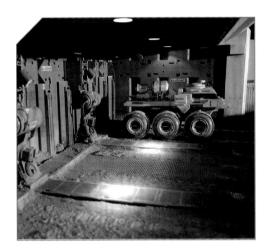

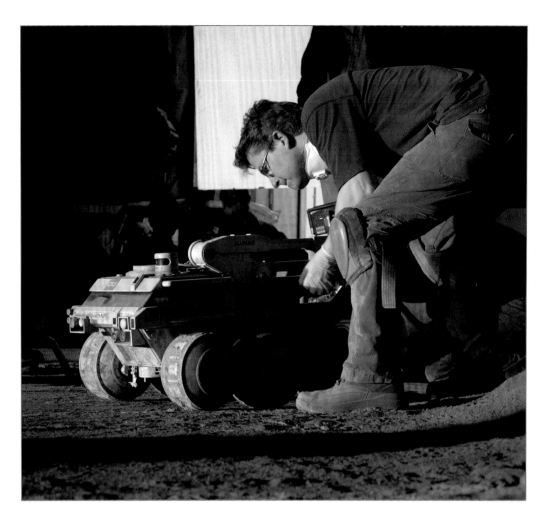

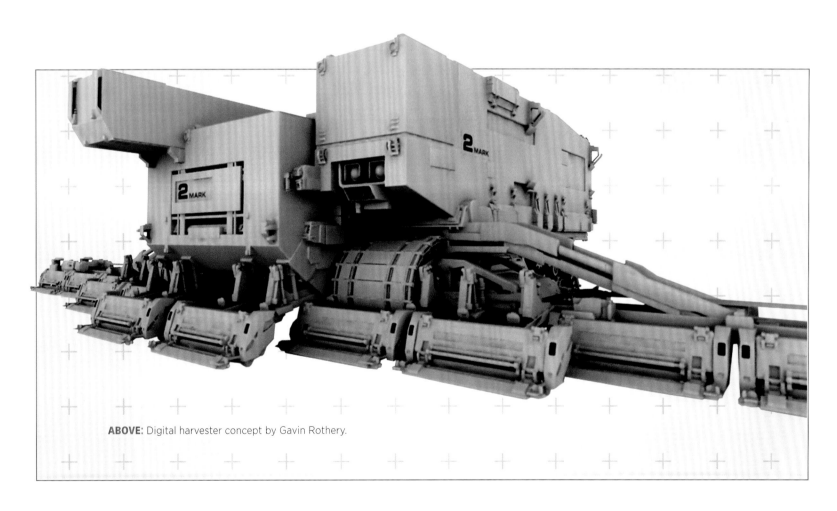

ABOVE: Digital harvester concept by Gavin Rothery.

Bill in turn brought in a team of very experienced model effects artists: John Lee, Steve Howarth, Chris Hayes, Ron Hone, Richard St. Clair, plus trainee Lee James. Additional help was on hand when Pearson brought in Peter Lee, who joined the crew during the complex moonbase installation, part way through the shoot. It was still somewhat up in the air just which effects would be digital and which would be practical. "The budget was very tight, so word filtered out that full CGI just wasn't an option for the amount of on-screen action, with moon rovers, harvesters, and recovery vehicles, etc. I think the decision to go down the miniatures route was probably part budgetary, part aesthetic," senior model maker John Lee explains. "It helped that we were all ready, and raring to go – and could complete the model work in less than three months."

The work of the miniatures team grew somewhat from their initial brief, according to Pearson. "They wanted two space helmets from us. That was it. And we ended up doing set dressing, making two suits, all the miniatures, and building Gerty. It was the most I've ever done on one film."

There was a genuine thrill on set of working together and bringing things to life using one's hands, imagination, and the resources within arm's reach. Digital effects via computer can be a solitary business, but a model shop is a hive of interaction and collaboration.

"The feeling in the model workshop was that *Moon* would either become a classic, or would be forgotten without trace. I was in the 'cult classic' camp, so without hesitation I threw myself into it," reminisces John Lee. "My feeling was, and still is, that these films don't come along that often, so on *Moon* the stars seemed to align. Here was a chance to work on something that could stand the test of time, and maybe become a cult classic.

"Duncan is a massive science fiction fan and one of his favorites is *Aliens*, for which I'd worked on the model effects unit back in 1985/86," Lee continues, "so we'd always get into discussing it. The fact that almost all of the FX work on *Aliens* was practical and in-camera was something that Duncan admired. It was always a joy when he visited

BELOW: Three stages of 1:12 scale harvester under construction. Initial shapes were fabricated from Foamex, and detailed by Steve Howarth.

OPPOSITE TOP: Cinematographer Peter Talbot setting up a shot of Sam's crashed rover, with rover 3 about to be pulled into shot.

OPPOSITE BOTTOM: Digital harvester designs by Gavin Rothery.

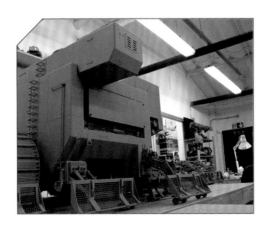

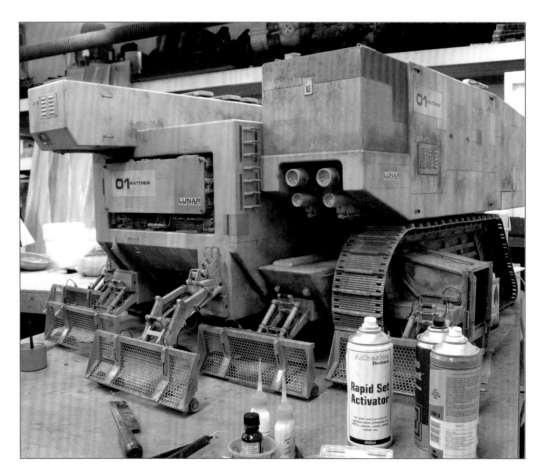

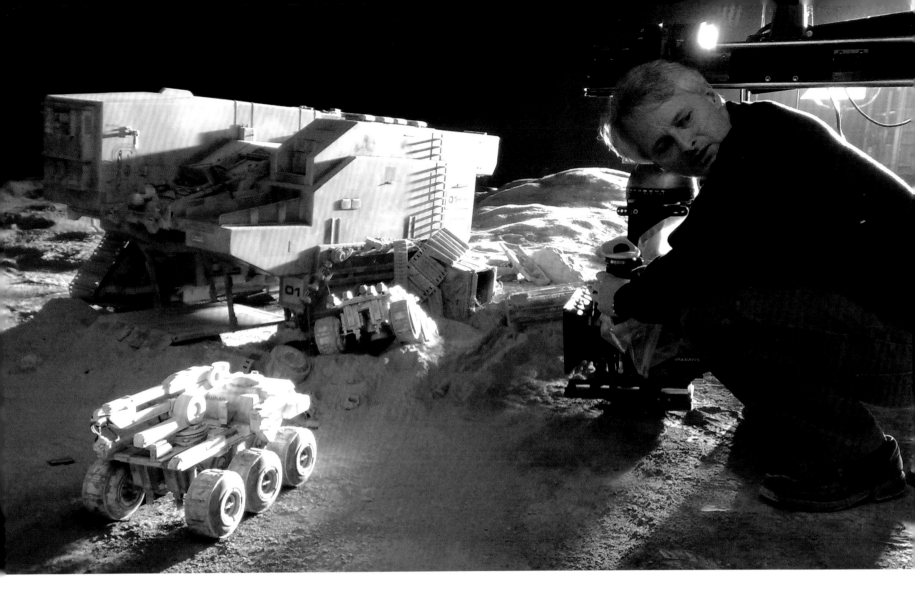

the workshop, which was quite frequent. Duncan was very down to earth, and incredibly excited when he and his concept designer Gavin Rothery began seeing the models take shape. He must have known they were onto a winner. Duncan knew his stuff, so I felt we were in safe hands."

This went both ways, as it is for exactly this same reason of "knowing their stuff" that Pearson, John Lee, and the rest of the team were hired for *Moon*. "We tried to anchor the project with a couple of experienced people," Jones confirms. "It's interesting because everything gelled together and everyone felt like we were working together – but it was us younger people with these experienced people around us going, 'Wow, you worked on *that*?'"

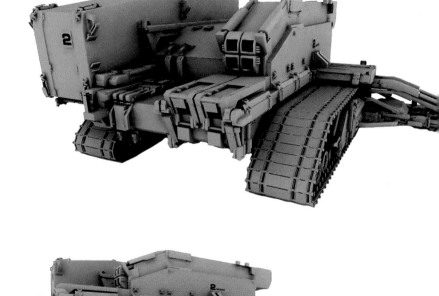

> "THE DESIGNS AND CONCEPT WORK WAS DONE BY GAVIN ROTHERY, [WHO] PROVIDED US WITH SOME REALLY NICE ARTWORK. WE MADE THE MODELS AT 1:12 SCALE, WITH ONE LARGER 1:6 SCALE ROVER FOR CLOSE SHOTS."
>
> **JOHN LEE** *SENIOR MODEL MAKER*

Pearson, John Lee, and Howarth had made a career out of miniatures work and knew all the tricks, including how to add in texture and detail using found objects. These informed both the inside of the rovers and the exterior of the base. "Vacuum forming would have taken time and money," Howarth explains. "Sheet metal and a huge variety of objects are what we used. We found some old toilet paper dispensers in a skip out the back – that's what you can see over the bay. If you look closely you'll see the hole for the key still in the top… There's backs of toy cranes and printer cartridges on the top of the base. There was simply no time to follow all the designs. No time for hesitation. Duncan and Gavin let us get on with it – nothing would have ever been finished otherwise."

The rovers Sam traverses the surface in perform a key story function. The models were built in two different sizes, one for mid to long shots, and a larger scale for close-ups. Occasionally, however, both scales were combined in the same shot to create a forced perspective within the scene. "Steve Howarth was making the first small 1:12 scale rover from acrylic, Foamex and styrene when I started," says John Lee, "so I used that as a basis to make the large 1:6 scale rover, which I started building on my first day. I simply doubled everything up in size to 1:6 scale, and added a logical amount of additional surface detail that might be visible considering the camera would be much closer. I used Foamex to make the basic construction, as it's lightweight and very strong, and added plasticard details and cast elements, which I patterned and molded, like the detail that went into the wheel hubs, and the 'gubbins' behind the wheels. During the rest of the first week, I fleshed out the cab, built the first level of details on the cab roof, hatch, and lighting, and blocked out the other two rover backs. Ron Hone made the large-scale wheel assembly, as it needed to steer with radio control whilst also being pulled along with fine tungsten wire. When it came to making the different backs for rovers 2 and 3, I had a free hand to do what I pleased. In the script, one of them was referred to as a 'recovery rover,' so I imagined it might have a turntable and lifting gear on the back, and rover 3 could have been used for refuelling, or whatever. We used the same 1:6 scale wheel assembly and cab, and simply swapped the backs whenever we needed to shoot another rover. I obviously followed the same design aesthetic that Gavin came up with, so that all three vehicles looked like they came from the same factory.

BELOW LEFT: Early fabrication of the moonbase taking shape in Pearson's workshop at Shepperton Studios. Built primarily from injection-molded crates and found objects.

BELOW RIGHT: Escape vehicle built by John Lee with a 1:12 scale action figure for scale.

OPPOSITE TOP: Installing the moonbase part way through the miniature shoot with Hayes, Howarth and Peter Lee. Grey felt cloth can be seen draped over sand sculpted moon terrain, prior to moon dust being applied.

OPPOSITE BOTTOM: Final dressed moonbase, with escape vehicle in foreground.

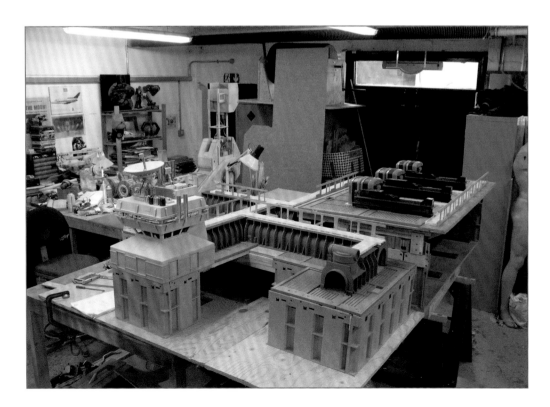

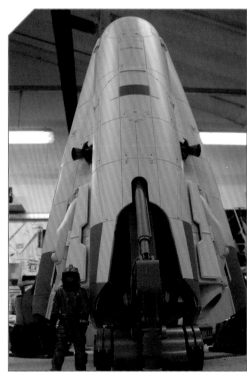

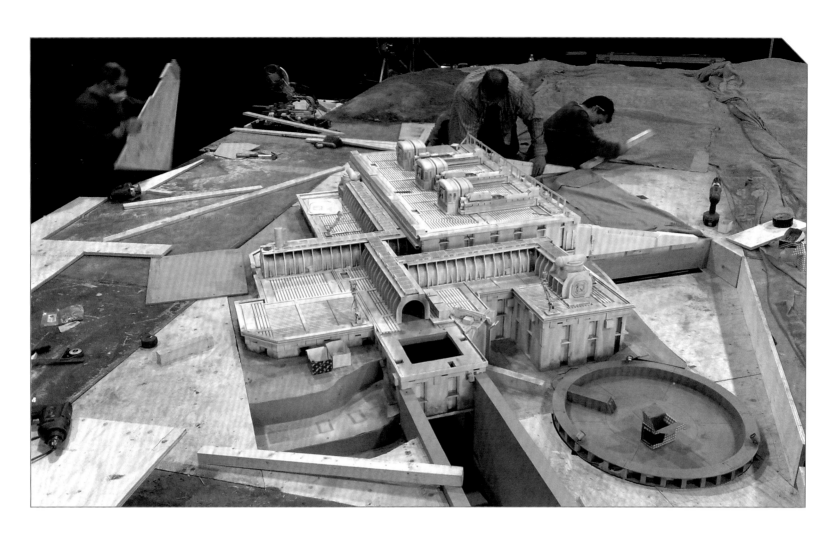

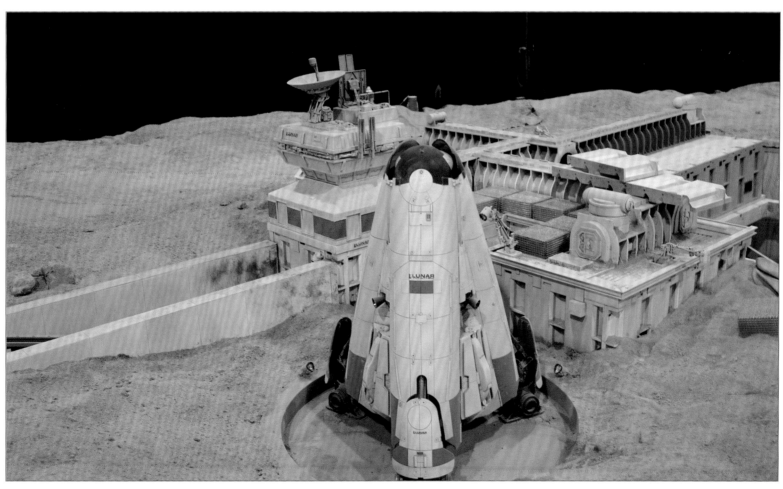

"Once I had completed the three large backs, which took fifteen days, we simply reproduced them on a smaller scale," Lee continues, "so Chris Hayes helped with that. On a project like *Moon*, where there is simply not enough time, the model work has to be split up, so a number of modelers worked on the same vehicles. Ron Hone is an experienced SFX engineer, so he was the best person to look after the undercarriage and wheel assembly for the 1:6 scale rover, complete with radio control steering, and Sam puppet inside. The Sam figure was converted from a twelve-inch-high action figure. The chunky rover wheels were made by Chris Hayes and Richard St. Clair, so they too had to be made accurately, and molded well, as the vehicles would be pulled along the moon's surface on tungsten wire in front of the camera. Chris was molding the large wheels on my first day at work. He works very accurately, so we knew they would be good."

The miniatures shoot took place after principal photography with Sam Rockwell had finished. The crew moved over to an additional soundstage in Shepperton, and started figuring out how to build the moon.

"We went into one of the smaller stages and built a complete rostrum," recalls production designer Tony Noble of the thirty-five by twenty-four foot moonscape built by John Lee and Hayes. "Then we had to put a lunar surface in. What do you use for a lunar surface? I'd always thought of using Fuller's Earth. It's like a dust. It's a natural product. But it turns out that because of all the terrorist scares it's been banned, you can't get it – it can be used for bomb making. I eventually ended up bringing in cat litter. I had tons of the stuff and we just filled this rostrum with it. It looked great. We could build it up and the rover would just trundle across the surface. People talk about all the motors and radio controls in mechanical rovers, but of course we had just a model with a piece of string pulling it across – just get rid of the string in post. And it works! No argument."

BELOW LEFT: 1:12 scale rovers and harvester crash site.

BELOW RIGHT: On set modeller John Lee set dressing the rover crash site with director Jones applying fine moon dust.

OPPOSITE TOP: Model unit director Jones checks the monitor whilst setting up a shot of the rover about to leave the garage.

OPPOSITE BOTTOM: Rovers 1, 2 and 3 outside the Sarang Base.

NEXT SPREAD: Due to the relatively small area of moon surface constructed by the model makers, high-angle stills shots were taken from the studio gantry and stitched together in post-production to create an even larger moonscape.

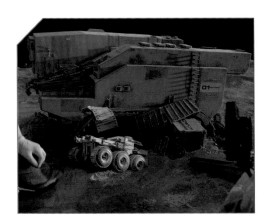

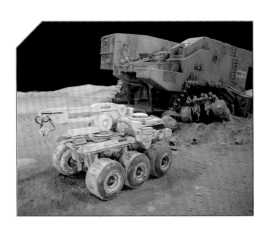

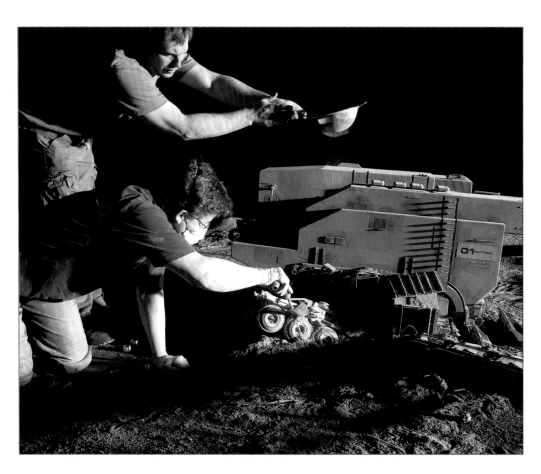

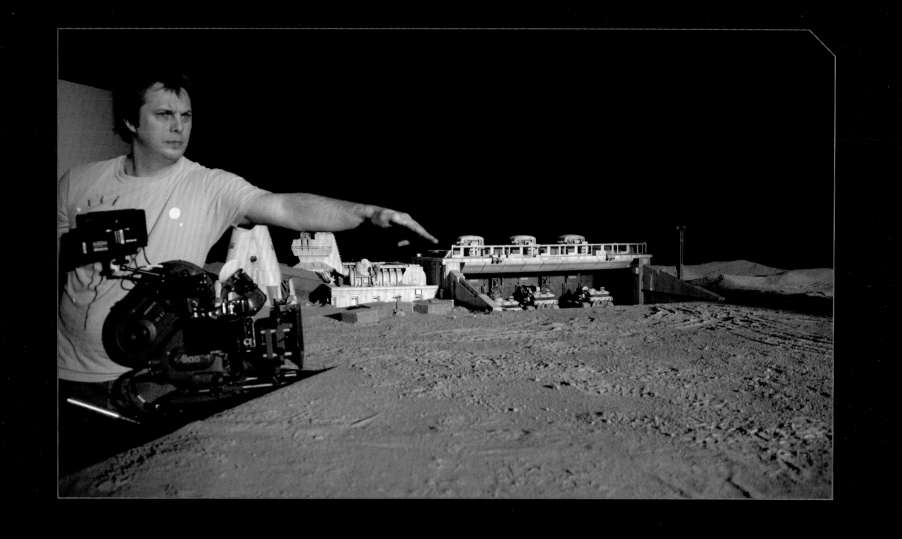
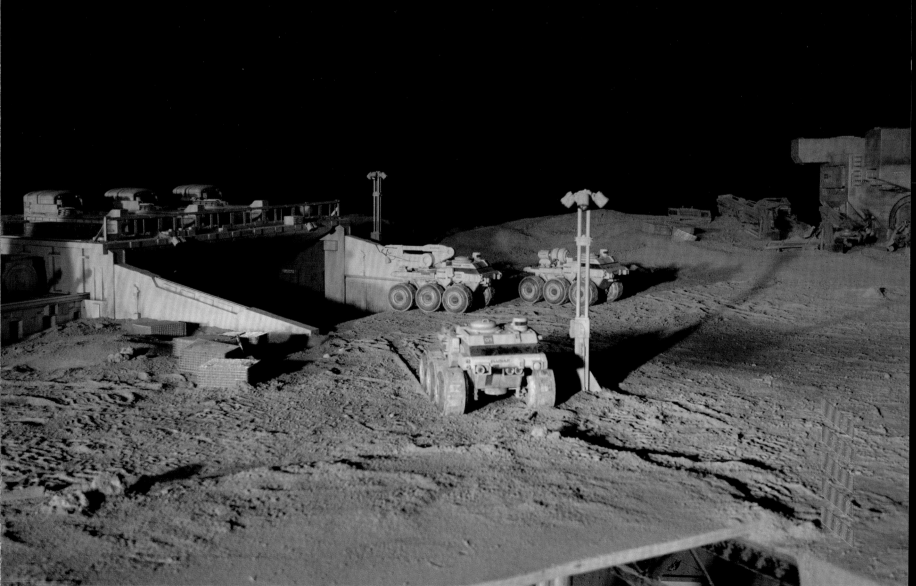

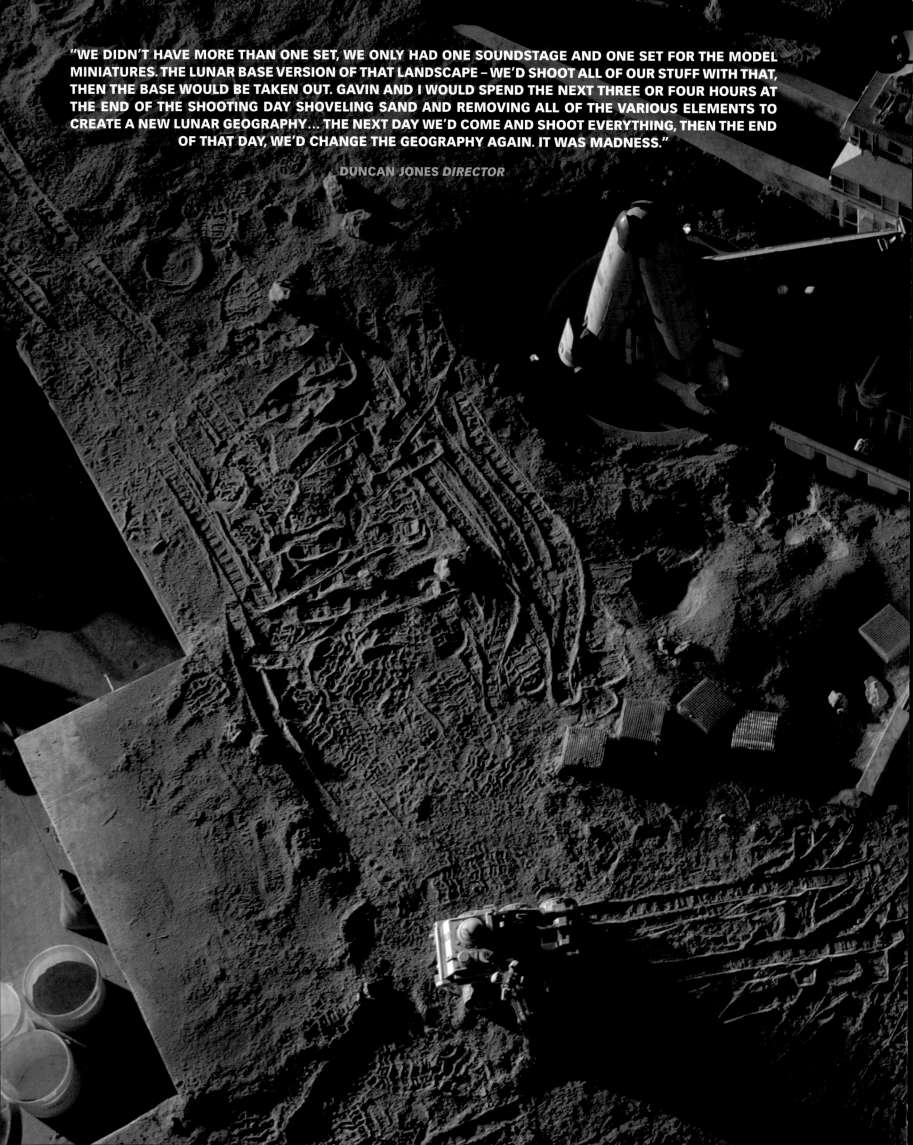

"WE DIDN'T HAVE MORE THAN ONE SET, WE ONLY HAD ONE SOUNDSTAGE AND ONE SET FOR THE MODEL MINIATURES. THE LUNAR BASE VERSION OF THAT LANDSCAPE – WE'D SHOOT ALL OF OUR STUFF WITH THAT, THEN THE BASE WOULD BE TAKEN OUT. GAVIN AND I WOULD SPEND THE NEXT THREE OR FOUR HOURS AT THE END OF THE SHOOTING DAY SHOVELING SAND AND REMOVING ALL OF THE VARIOUS ELEMENTS TO CREATE A NEW LUNAR GEOGRAPHY... THE NEXT DAY WE'D COME AND SHOOT EVERYTHING, THEN THE END OF THAT DAY, WE'D CHANGE THE GEOGRAPHY AGAIN. IT WAS MADNESS."

DUNCAN JONES *DIRECTOR*

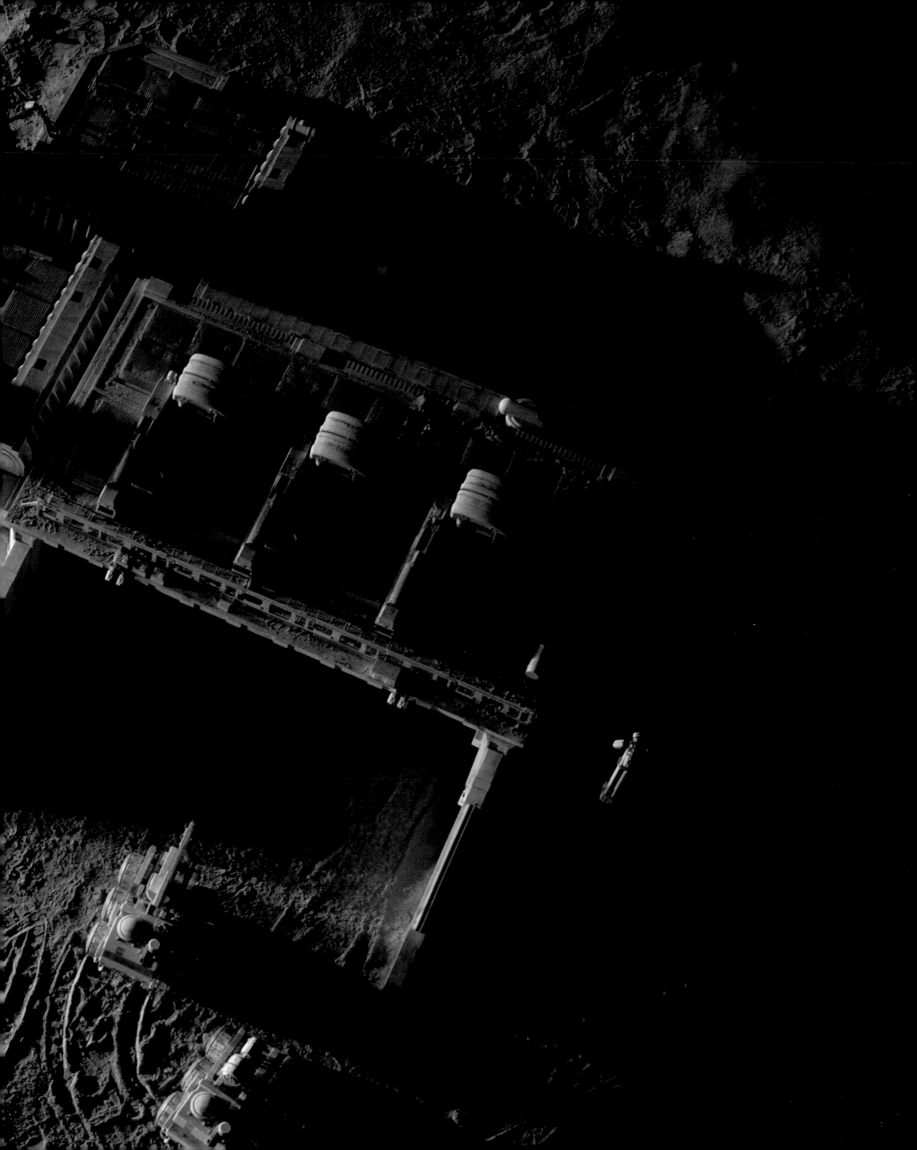

Pearson, however, remembers it differently. "I really screwed up in a big way with the rovers," he says. "I grew up admiring Derek Meddings. He would do great vehicles that kicked up a load of dust and that gave them so much momentum. I said, 'We need a day of testing, then we'll watch it on a decent sized screen.' We did the test and I was dead pleased. Then Duncan said to me, 'What the hell is all the dust? We're on the moon!' I said, 'Fuck!' The gravity is different. He showed me a tape of a rover kicking back waterfalls of debris. I thought, 'Shit! We're shooting tomorrow.'

"We couldn't do the dust in cement – health and safety. Can't have that kicking up into the air and getting inhaled," Pearson explains. "Duncan said he'd do the waterfall effect in digital. So I sprayed the set after every take to keep the cat litter down. Then the wheels of the rover picked up solid lumps of litter. It looked great, realistic, like what would actually happen in that situation on the moon. I said I had always planned that – which was bollocks! It's lucky effects, winging it. You can't plan for everything."

But they planned for what they could, with preparation and experience mitigating the pitfalls that many first-time filmmakers can face. Being scientifically accurate was of the utmost importance to Jones. The more believable the world of *Moon* is, the more easily the viewer can associate with it, without overt artistic license breaking the illusion. With this in mind, for the exterior model shots they brought in a specialist director of photography.

"He had been recommended by the team at Cinesite," Fenegan recalls, "who had worked with him on some of the *Harry*

BELOW: Cinematographer Talbot setting up a shot of the moonbase, with Howarth and John Lee carrying out final adjustments to the models in foreground.

OPPOSITE TOP: Set dressers regularly spritzed down the atmosphere before each take to reduce the amount of airborne dust particulates that tended to float around in camera.

OPPOSITE BOTTOM: Sarang Base.

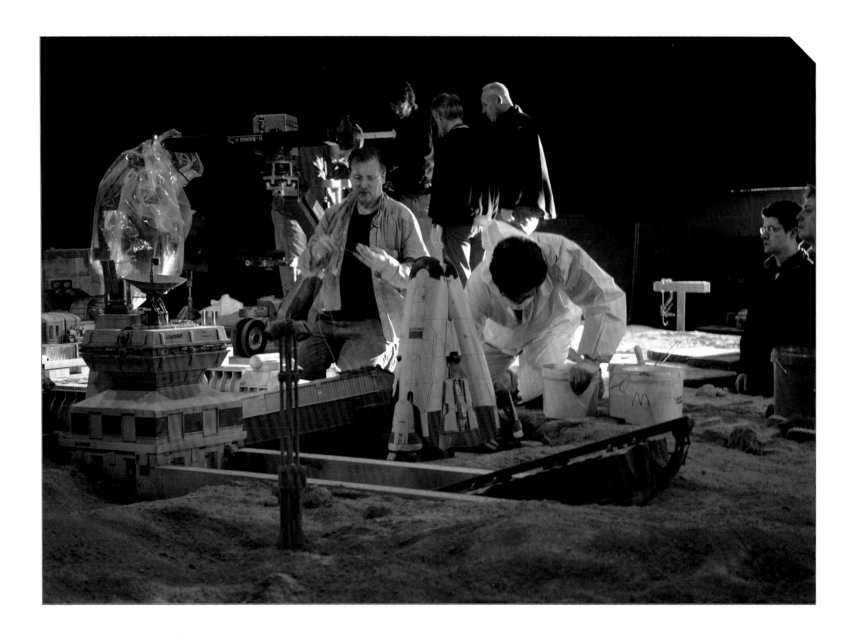

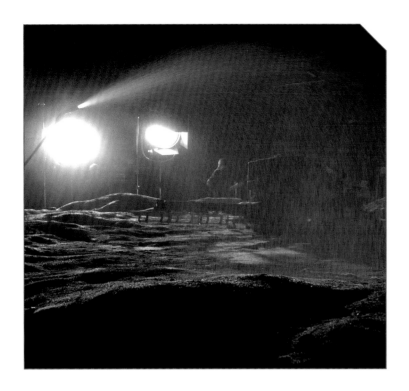

Potter model miniatures effects work."

"That was an amazing guy called Peter Talbot, who is a cinematographer," says Jones. "He does all sorts of cinematography, but he is very much known for model miniatures work. He was very experienced and he had this entire mathematical equation that he'd come up with for the size of the vehicles for lunar gravity, what frame rate you needed to shoot at in order to replicate gravity for objects that big on the moon. He was fantastic. Really really amazing."

The cohesiveness and consistency of *Moon*'s aesthetics create a viable world, one that perfectly matches Sam's character – a little worn, a little bruised. It all complements his life, and in reality the effects were there to help Sam Rockwell believe the situation. "The film is all about Sam Bell," confirms John Lee. "The model effects we were creating are always secondary to the main focus of the film. However, saying that, Duncan and his team were always very complimentary about the work we produced, because I think he knew that deep down we really cared about the work, and gave above and beyond what was required. We were really happy to be working on a film like this."

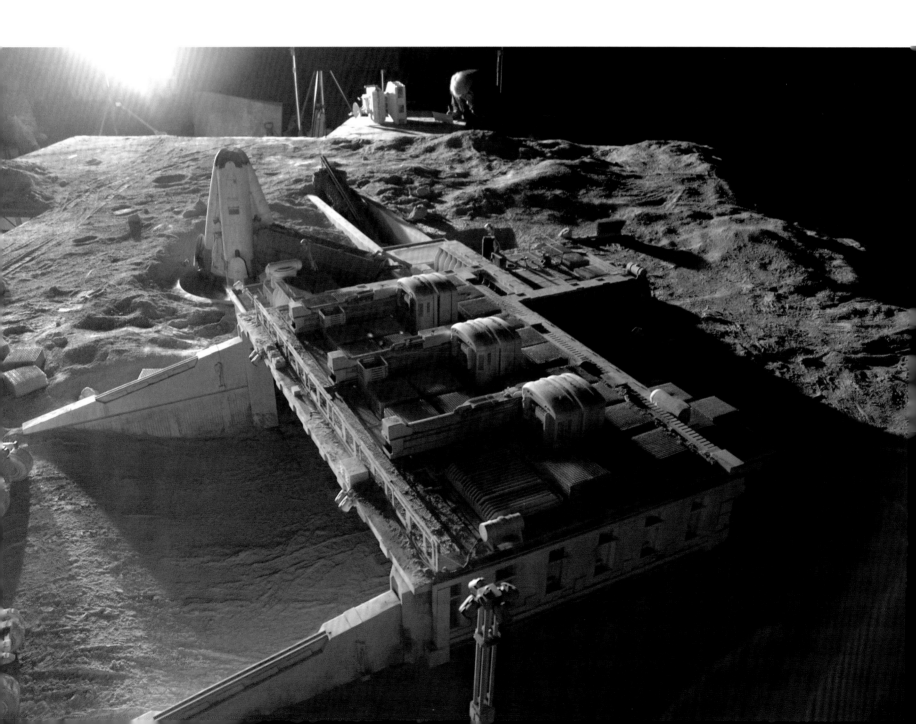

Nowhere was it more crucial that Sam Rockwell had something "real" and tangible to work off than with Gerty. The beloved robot co-star is ambiguous and hard to read for much of the movie, daring audiences to believe he is betraying Sam before being true to his word: that his purpose is to keep Sam safe. With his simple boxy design and inspired emoji expressions, Gerty was immediately iconic. If it is possible for a film with only three main roles to have a breakout character, Gerty was it.

But he wasn't initially designed for *Moon*. The seed (or motherboard) of Gerty's look was a commercial Jones, Fenegan, and Rothery made in 2007, whilst Nathan Parker was drafting the script for *Moon*.

"There's a commercial we did for a non-alcoholic Carling beer called C2. About nine seconds in you can basically see Gerty's mummy and daddy," Jones explains. "The middle one, our hero, is suspended like R2-D2 from the ceiling, travelling around on a rail. On the left-hand side is a robot made out of old PCs and Macs and that's essentially what Gerty was. That was kind of the design. It's got the graphic screen and everything. Gavin and I had always been playing around with the idea that it would be kind of fun to make a robot that was made out of a bunch of old gaming PCs and old computers, so that's how that guy came up. When we got around to doing Gerty, Gavin was playing around with a couple of ideas and was going very seventies. It almost had these disco ball-looking things that he was playing around with."

BELOW: Close-up of Gerty.

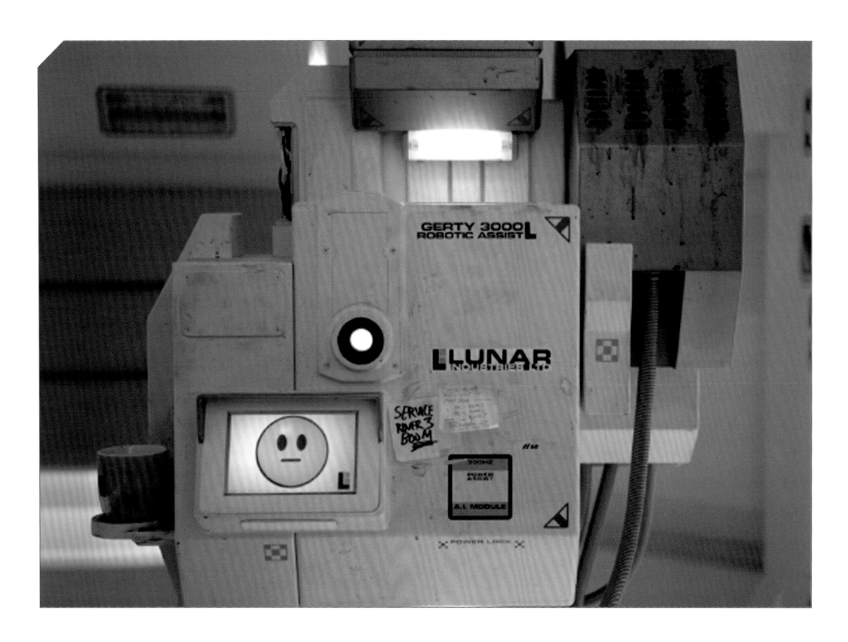

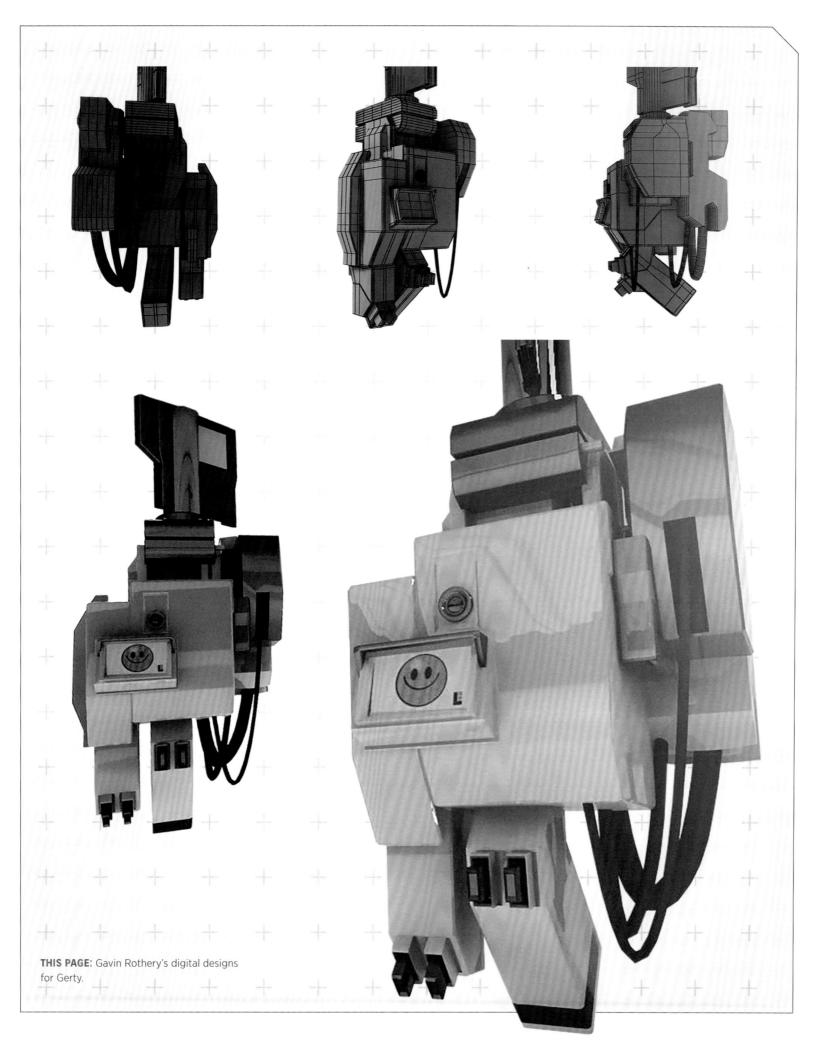

THIS PAGE: Gavin Rothery's digital designs for Gerty.

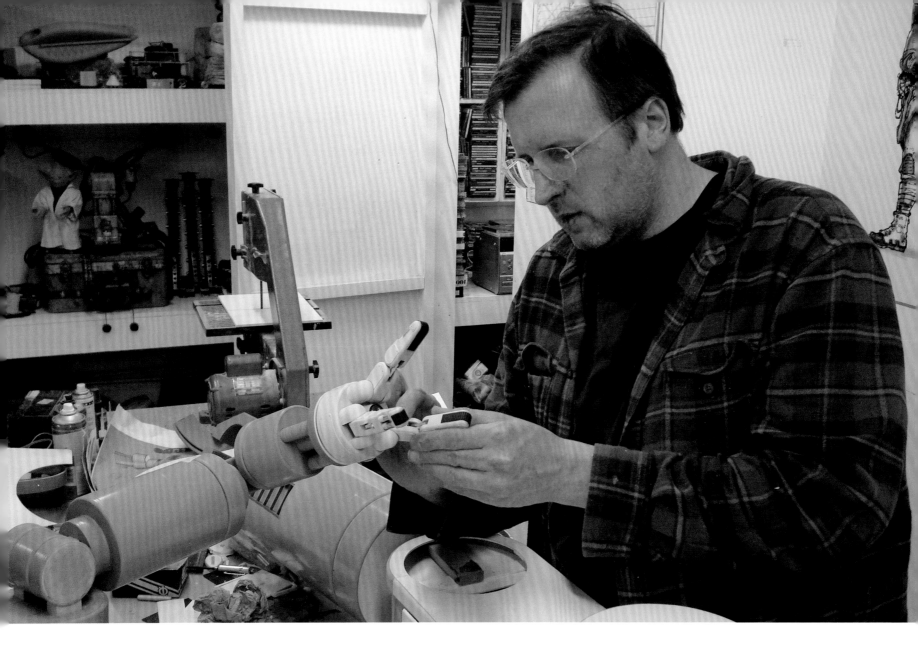

ABOVE: Senior model maker Howarth working on the mechanical hands for Gerty.

BELOW: Close-up shots of Gerty's hands under construction.

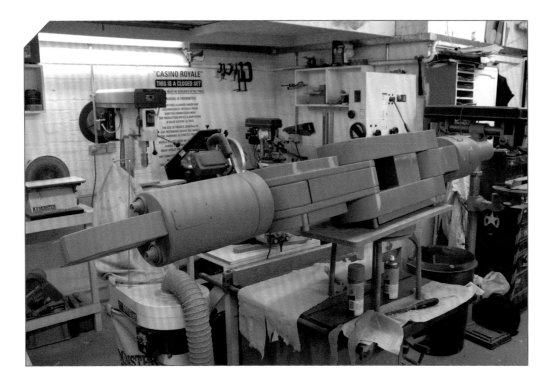

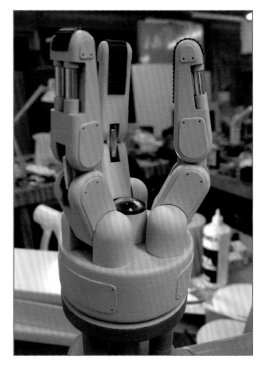

MAKING MOON A BRITISH SCI-FI CULT CLASSIC

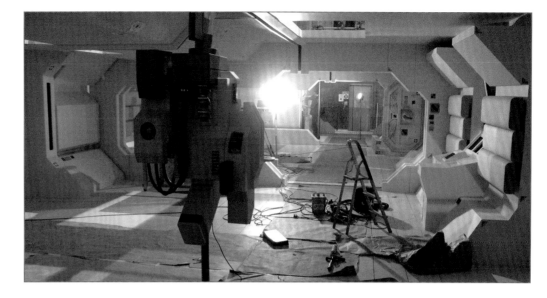

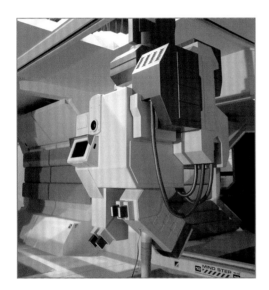

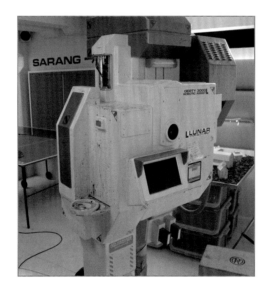

"But," continues Jones, "I said, 'I like those crappy robots we made, where we were kind of bolting old PCs together,' and that's where we came up with Gerty. There's lots of DNA in the Carling advert. If you go to around fifteen seconds you can see in the background window past the bar there's a bunch of big robot automated arms doing their thing as well. There was definitely a thinking already going on about what we liked and what we'd want to do."

They knew what they wanted to do and tasked Howarth with building this C2 "mark 2" robot. Even though much of Gerty's movement and arm work would be done in post-production via CGI, there was a real model prop on set for Sam Rockwell to interact with. "I followed Gavin's drawings closely," Howarth says. "I made a cardboard cutout, which Duncan okayed, then I cut the pieces out. The final version was made out of Foamex, which is wonderful stuff – you just knife it and superglue it. It's just slightly harder than parmesan cheese… There were no designs for the arms, so I had to draw them, then built them with a lens Bill gave me, along with a cable release."

TOP LEFT: Gerty under construction. The carcase was made from Foamex, and detailed with styrene and plastic parts.

TOP: Gerty on set.

ABOVE: Concept sketches for Gerty's emoticon expressions.

In the movie, Gerty travels via a rail in the ceiling, but in reality he was never hung. There was only one Gerty model, which was on a stand, which Howarth delivered clean. Then Pearson suggested graffiti and marker pen and suddenly Gerty was covered in graphics and Rothery was throwing coffee at him.

Gerty would not have the same personality if he had been made digitally. As an effect, he could run the risk of ageing as visual effects evolve, but as a model perfectly suited to his surroundings, he is timeless. But handmade effects or, as Pearson calls them, "string and Sellotape work," is increasingly a thing of the past, as Jones cautions. "With the move to 4k the props themselves have to be built to a whole different level of detail. At 4k you're going to see the glue seams, the paintbrush strokes. You have to build a higher level [of detail], that takes more time, that takes more money. So even though it's the same technique, it does make the challenge of doing in-camera stuff harder again."

The miniatures and model work in *Moon* certainly holds water, and was singled out for acclaim in many reviews, by critics and fans alike. Famous fans, too.

"I was at the bar after the screening," remembers Pearson. "The producer Trudie Styler was there, as was her husband. And Sting said to me, 'It's so good to see model work again.'"

BELOW: Gerty in the docking station next to the communications station.

OPPOSITE: A page from Jones's shooting script.

Sam 2 pulls a face, disgruntled, continues down the corridor.

62 INT. SLEEPING QUARTERS -- CONTINUOUS 62

Sam 2 takes in a Tennessee football team poster on the wall, the old boxing trophies and Lunar health, hazard and qualification notices on the walls. He walks over to the bed -- studies his lucky tambourine and the glass jar of lunar rock samples -- like he's trying to reacquaint himself with his own belongings.

His eyes arrive on the red stress ball. Sam scoops up the ball and PITCHES it at the wall like he expects the thing to bounce back to him. The stress ball doesn't bounce back, simply hits the wall with a dull THUD and DROPS to the FLOOR.

 CUT TO:

63 EXT. THE MOON -- MORNING 63

A desolation special. The blacker than black sky above. None of the ingredients of life. On Earth we have rainforests, and flowers, and birds. We have color. Up here we realize how lucky we are. The base is lit by large halogen comfort lights, alone in the lunar desert. This is a lunar night.

 CUT TO:

64 INT. MONITORING STATION -- DAY, LATER 64

Sam 2 sitting before The Old Man doing a few innocuous tasks, collecting readouts, slurping a cup of coffee. Gerty is within ear shot.

Sam 2 sees something that pulls him CLOSER to the monitor.

 SAM 2
 Gerty, do you know about this?

Sam 2 taps the screen.

 SAM 2 (CONT'D)
 Matthew's got no velocity read-
 out. He's completely still.

 GERTY (O.S.)
 He must have stalled.

Sam 2 gives Gerty a look. That's not good.

MINI MOON THE MINIATURES

CINESITE
VISUAL EFFECTS

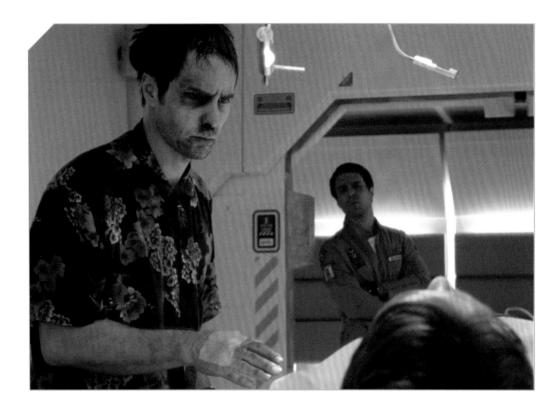

ABOVE: Sam 1, Sam 2 and a newly-woken Sam Bell clone.

ven a low-budget movie requires some level of visual effects. This can range from in-camera tricks to digital fixes in post-production, or more elaborate CGI sequences (as opposed to special effects, which are practical, on-set effects). *Moon* contains all three. There are no blockbuster action sequences, quite the opposite. Instead of the visual effects taking the film more into the realm of fantasy, they serve to convince the viewer of the reality of what is on screen.

No matter how much or little budget a film has, the production team obviously want the finished work to look as convincing as possible. This meant that after shopping the movie all round town for distribution, Duncan Jones and Stuart Fenegan now had to visit every visual effects house they could to get them on board a project that was starting shooting in a matter of weeks.

"I had a deal in place with a different visual effects house all the way through prep," explains Fenegan, "but then they had a capacity issue that meant they had to decide where they were going to deploy their visual effects equity investment. I hadn't closed the Sony deal and the effects house felt that they couldn't wait, and they needed to guarantee that they were putting those resources into a movie that was 100% going to shoot in January. Because I didn't have distribution, they put their money and resources into a different project. Understandable, but a real blow to my finance plan.

"I remember going round with our breakdown, and I had to redo the budget to find out how much actual cash money I could spend on visual effects," Fenegan continues, "not a contribution with an equity portion, just a straight, 'I will pay this much for these many effects.' Duncan, Gavin Rothery and myself went round with the visual effects

ABOVE: A digital storyboard sequence for the Sam 2 discovers Sam 1 scene.

breakdown and the CD fly-through of the moonbase that Gavin had created for us, and the design of Gerty and the Apollo *Full Moon* 70mm photographs that were used in our pitch document. We went into four visual effects houses. This was in the first week of December, so you can imagine how down to the wire it was for production. We went in and Duncan explained the vision for the movie, and I then said, 'Okay, it's 400 shots, I have this much money, and we start January 14th and I need an answer within the next five business days. Thanks very much!'"

Their vision, professionalism, and perhaps sheer willpower was rewarded with a Christmas miracle. "We'd just had the staff Christmas lunch at a pub very near Shepperton Studios," continues Fenegan. "I'm in a car heading to the station to get the train back into London and I get a phone call from Antony Hunt, the head of Cinesite. He said, 'Happy Christmas – you have a visual effects deal.'"

Initially based in Los Angeles and London, Cinesite are one of the world's leading effects houses, having worked on all the *Harry Potter* films, much of the Marvel Cinematic Universe, James Bond, and *Pirates of the Caribbean*. But their work is not dedicated to large-scale set pieces and blockbusters, as films such as *Lock, Stock and Two Smoking Barrels* and *Buffalo Soldiers* rub shoulders with *The Dark Knight* and *Clash of the Titans*. From the subtle and invisible to the impossible, Cinesite were wonderfully placed to take on *Moon*. And *Moon* was exactly the sort of film they were looking for at that time.

"The writers strike was coming up," remembers visual effects supervisor Simon Stanley-Clamp, "so we wanted to work with some new, exciting start-up films. They came to us with *Moon*, with a presentation, but the script was why we wanted to do it. It was a standout script, and for our work I broke the script down shot by shot."

A common misconception is that VFX departments only become part of a project once the shooting is all finished, but that is not the case and could not be further from the truth when it came to Cinesite's involvement on *Moon*. Stanley-Clamp and visual effects producer Angie Wills were on set every day for the entire nine weeks, supervising the main units and miniature units, gathering texture references, and, vitally, using high dynamic range imaging (HDRI) to create a lighting map for each scene. "This was a digital build of the whole set, completely accurate of the actual, physical set. It helped us plan the lighting, especially how Gerty worked in light and reflections."

BELOW: Final shots from the Sam 2 discovers Sam 1 scene.

OPPOSITE: A page from Jones's shooting script.

10 EXT. LUNAR LANDSCAPE -- CONTINUOUS 10

 The empty terrain surrounding the mining base, as viewed
 from the Monitoring Station window. Across the landscape a
 mountain rises from the morning shadows.

 SAM 1 (V.O.)
 That, and I don't want to make *
 Gerty embarrassed. *

 CLOSE UP -- A HAND TOOL

 Some kind of rake or shovel half buried in the powdery
 soil, like a child's toy abandoned in a sand box.

 SAM 1 (V.O.) (CONT'D)
 You miss daddy, baby? You want me *
 to shave this big old beard off *
 before I get back? You still *
 going to recognize me? *

11 EXT. EARTH -- AS SEEN FROM THE MOON - CONTINUOUS 11

 From up here it is easy to see why the Earth is sometimes
 referred to as "the blue marble." A swirl of color.

 SAM 1 (V.O.)
 I miss both of you sooo much! I
 can't believe I'm coming home!

12 INT. SLEEPING QUARTERS - CONTINUOUS 12

 Sam 1's bed -- A New York Jets poster on the wall -- a few
 knickknacks bedside, rock samples in jars, a lucky
 tambourine Sam got in Mexico some years ago -- a red stress
 ball -- a photograph by the bed in a frame --

 SAM 1 (V.O.)
 I love you.

 We MOVE CLOSER to the PHOTO by the bed.

 PHOTOGRAPH

 Of a slightly younger and clean-shaven Sam 1 with his arms
 wrapped around his wife of four years, TESS BELL.

 Tess is a far cry from the stereotypical Astronaut's Wife
 of the 1960's/70's with the plastic smile and beehive
 hairdo.

Gerty was, of course, a major component. Essentially playing the third lead of the movie, if he had been anything less than convincing it would have broken the suspension of disbelief and done a disservice to Sam Rockwell's performance.

Of the physical model of the amiable robot assistant, Stanley-Clamp confirms, "He barely moved. Things kept breaking; snapping off. So whenever it is freestanding it's CGI. The arm is all CGI." Originally, a puppeteer with fishing wire had been tasked with operating the arm and making it posable, but every time something didn't work it ended up costing time and money, making it ultimately more cost-effective to use digital effects.

The *Moon* crew had planned very carefully how much budget they had for effects, letting the miniatures unit handle the practical harvesters and rovers work. With Cinesite on set during filming, it nonetheless came down to a daily conversation about where the funds could be best allocated. "We had a budget that we knew we wanted to spend on visual effects and we had come up with the plan with Simon Stanley-Clamp," Jones explains. "'Let's pretend we have a bag of marbles and when we decide on the day that we want an effect we'll give you some of the marbles and you tell us how many marbles there are so that we know we have some marbles left for the end of the shoot.' Essentially we were trading all the way through the shoot. You'd think that with such a miniscule budget you'd have everything planned out meticulously beforehand, but we really didn't."

The most important visual effects work by far was convincingly selling two Sam Bells in the frame at the same time. Much of this believability would come from Rockwell's incredible performance, but that needed to be supported by either old-fashioned camera tricks or the best state of the art technology.

THIS SPREAD: Creating the scene when Sam 1 has a vision of a girl in a yellow dress on the moon, with storyboards (opposite top), shot elements of Sam Rockwell and Kaya Scodelario (below) and a final frame (opposite bottom).

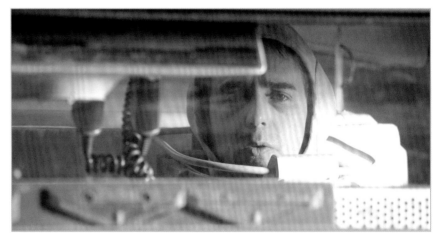

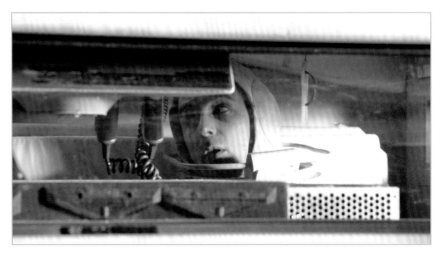

 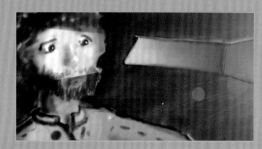

"We knew that there were different ways that we could do the effects," continues Jones. "There were very simple split-screen sequences, where two Sams would be separated by space and the camera would be static. That is a very cheap visual effect for us to do. You shoot one side, you shoot the other side, you don't move the camera, then you just do a transition between the two elements that you shot."

For more complicated moments, Cinesite suggested the use of a programmable camera system called SPROG, the first time such a thing had been used on a movie like this. It was set up to perform the camera moves in a scene and could do so ad infinitum, meaning that the footage Cinesite would have to work with was guaranteed to be consistent and far easier to make split-screen composites with.

SPROG may have been entirely dependable, but so was the lead actor, able to physically repeat a scene impeccably after many hours had passed between takes. "Sam [Rockwell] would remember what he'd done and what he had to do," marvels Stanley-Clamp. "He was incredible at recalling where he was."

"The sound guy [Patrick Owen] helped me out quite a bit," Sam Rockwell reveals of his impressive recall. "He would put the previous take on my iPod, so when I was changing clothes and in the makeup chair I would watch the previous take to memorize the actions. It was very, very challenging technically."

One of the most overt effects sequences is the ping-pong game. Along with using a locked-off camera, the ball was painted in later with CGI, meaning Rockwell had to play against a non-existent opponent and remember each move – something he achieved by timing his moves to a metronome. What Stanley-Clamp did throughout the shoot – including on this scene – was put together "slap comps" to aid the actors. These were very rough on-set composites of clone versus clone created quickly and shown to Rockwell after a take to "Help him see if he was getting it right."

Despite his immense range, *Moon* would be Sam Rockwell's most demanding role yet, requiring him to delineate alternate versions of the same person and define each clone by their emotional and physical differences. This physicality was key not just in expressing character, but in selling the audience on the illusion that two genetically identical versions of the same man were sharing the screen. To this end, the filmmakers and visual effects team wanted to find moments where Sam 1 and Sam 2 could physically interact in a natural way.

BELOW LEFT: Shooting a scene where Sam 1 (Rockwell) and Sam 2 (Robin Chalk) physically interact.

BELOW RIGHT & OPPOSITE: The SPROG camera system on set.

NEXT SPREAD: Some Cinesite effects breakdown storyboards.

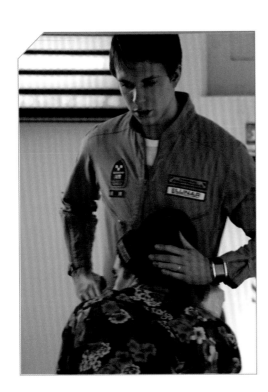

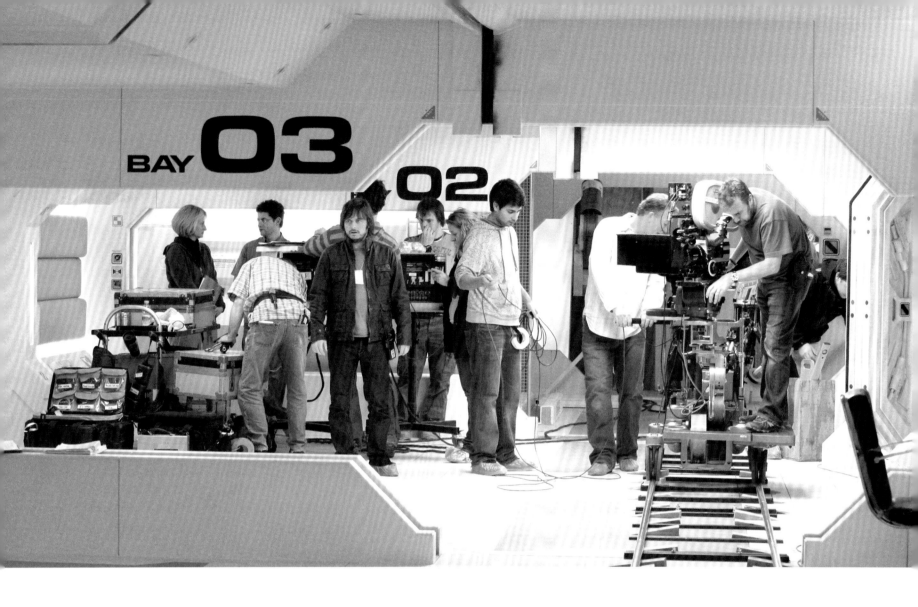

"Sam Rockwell had actually made a request: 'Look, it feels weird never being able to physically interact with him,'" says Jones. "So we said, 'Okay, let's work out a way we can do this and really go for it in a couple of scenes in the film,' so as an audience you don't feel like you're being cheated out of something, like we're trying to avoid doing something. Just go for it, but not do it that many times. So we have that one moment were Sam 1 is feeling sick and sitting down and the other Sam is standing above him and puts his hand on his shoulder. That was a really fun, complicated interaction where we had our stand-in's arm being used to fake Sam's arm when he was round the other side. It was a clever use of masking the join between the arm with Sam standing in front of it, with Sam sitting on the other end with the stand-in's arm actually doing the physical interaction."

In total, Cinesite delivered 270 effects shots and treated the film with as much dedication as a movie with ten times the budget, beginning a relationship between themselves and Jones and Fenegan which has continued. "Duncan is pragmatic and economical. He's willing to change his mind, but his personality is such that he makes you want to say 'yes' and do your best," says Stanley-Clamp. "We worked on *Mute* together, and have delivered a VFX breakdown for a future, currently unproduced project…"

Scene 122 - setup 1

"Cam on legs"
Suggested lock off for split screen

Plate 1
Shoot Sam 1 with Stand in as Sam2 for eye line and performance reference.

Plate 2
Shoot Sam 2 with Stand in as Sam 1 for eye line performance reference.

Plate 3 - Clean of performers same lighting.

Scene 122 - setup 2

"Wide Establisher - using Double"
Suggested lock off for split screen

Plate 1
Shoot Sam 1 with Stand in as Sam 2 for eye line and performance reference.

Plate 2
Shoot Sam 2 with Stand in as Sam 1 for eye line performance reference.

Plate 3 - Clean of performers same lighting.

Scene 122 - setup 3

"Medium on Sam 1"

Scene 122 - setup 4

"Over the shoulder on Sam 2"

Sam 1 - double in foreground, with back to camera, view over shoulder.

Sam 2 - principal, performing to double/camera.

All in camera - no plates required.

Scene 122 - setup 5

"Close up on Sam 1"

Scene 122 - setup 6

"Close up on Sam 2"

Scene 123 - setup 1

"Two Shot using double"

Sam 1 - double behind principal Sam 2

Sam 2 - principal

Scene 123 - setup2

"Sam 1 into bed"

Sam 1 - principal from standing to bed

Sam 2 - double helps into bed, poss from behind? - masking face.

Scene 123 - setup3

"Close up of back pack"

Scene 123 - setup4

"Sam 2 action"

Sam 1 - double on bed.

Sam 2 - principal for main action.

MEMORIES
CLINT MANSELL'S SCORE

MEMORIES
CLINT MANSELL'S SCORE

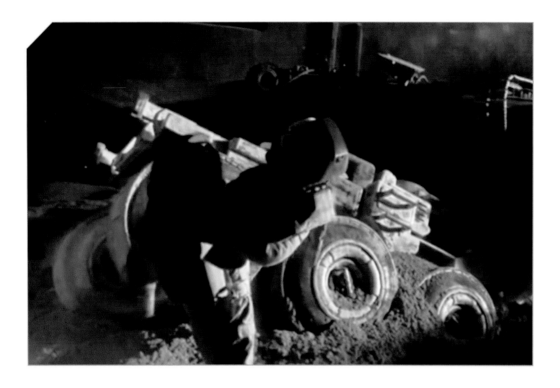

music is an inseparable part of iconic science fiction films. It is impossible to hear 'Also sprach Zarathustra' without thinking of its use in *2001: A Space Odyssey*; no scene of *Blade Runner* can be recalled without the synth-strains of Vangelis accompanying it; and the audience realizes they are watching something much stranger and more unsettling than a typical adventure film when Jerry Goldsmith's radical, experimental score introduces *Planet of the Apes* (1968). For *Moon*, the music is similarly essential and a perfect marriage of visuals and sound, guiding the viewer through the tones of the film as it shifts from eerie, through drama, melancholia, and eventually to triumph.

The filmmakers called on composer and musician Clint Mansell who, by the time *Moon* came along, had already established himself for his work with, among others, Darren Aronofsky. His compositions were associated with intelligent, emotional cinema, and *Moon* entirely fitted this mold.

Before officially agreeing to collaborate on *Moon*, Duncan Jones and Mansell had crossed paths previously and seemed almost destined to work with one another.

"I'd met Duncan about 18 months before through a friend. I literally met him in a pub one night," recalls Mansell. In 2006, "I did a film called *The Fountain* with Darren Aronofsky, and Darren thought it would be a cool idea to get David Bowie involved in it because of the spaceman in the film who's called Tom and, you know, you've got Major Tom in 'Space Oddity'. We'd met with David a few times and I'd played him my demos and stuff like that. That didn't work out, but a little time later, as I said, I met Duncan in a pub through a friend of a friend and he said, 'My dad says hello,' and I said, 'Who's your dad?' and he answered, 'David Bowie.'"

It was in the stars.

ABOVE: Sam 1's crashed rover.

After this initial meeting, the script for *Moon* came to Mansell through his agent. "I still think, pretty much to this day, that it's the best script I've ever read. I just thought it was fantastic. It had everything in it that I love: loneliness, isolation, what it is to be human, melancholy. It's just beautiful."

Mansell joined the film fairly late in the production and was able to work off a rough cut. Given the amount of post-production needed, there was sufficient time for him to craft the sonic sound and also discuss its direction extensively with Jones.

"The great thing about working on a low-budget movie is the fact that the one thing you usually get is time," explains Mansell. "You don't earn any money, but you do get time to do what you have to do. I don't think I was on it that long, but there wasn't a sense of pressure. Duncan sent me a rough-cut of the film. I mapped out some ideas, and sent them to him. He quite liked them. He came over to L.A. for I don't know how long, it might have been a week or just a few days, and by that time I'd sketched out bits of the movie and he really responded

to them. There were only one or two pieces that he didn't really dig, everything else was working for him. In essence we had the backbone of it. I seem to recall it being okay and going pretty well."

Three months is Mansell's ideal time frame for creating a score, but *Moon* came together more quickly and was recorded in California. Clint wrote the tunes alone, as he does for all his films, but after that stage he brought in his recording engineer and co-producer Geoff Foster and conductor Matt Dunkley. Altogether it was three to four days recording, followed by a week of mixing.

"I don't play well with others," says Mansell, "but I like it much more when I work closely with the director. For me the best collaborations are the ones where the two of you end up in a place where neither of you would have expected, and certainly couldn't have got there alone. Duncan will tell me what he's thinking, and then I bring those ideas back to him, how I've interpreted them, and we go back and forth. That to me is like a really natural and organic way of working."

BELOW: Sam 2 finds the crashed rover.

NEXT SPREAD: Sheet music for the 'Welcome to Lunar Industries' section of the *Moon* score.

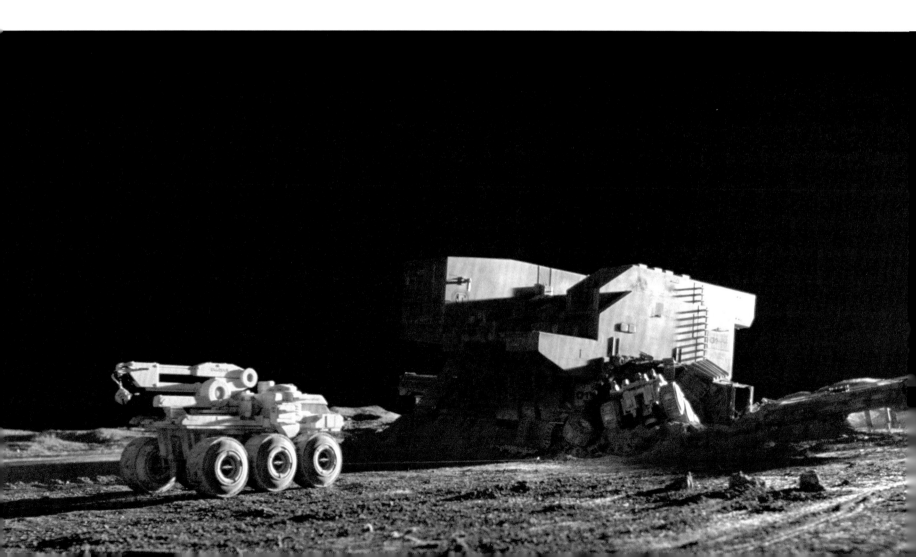

Welcome to Lunar Industries

Moon

Clint Mansell

As with every core member of the group, the collaborators were in tune with the feel of the movie and the influences upon it. Even if there were not direct references and call backs, Mansell realized early on that they were all speaking the same language.

"I loved *Silent Running* and thought that I was in an audience of one of people who liked that film, because at the time when I saw it – probably in the late '70s or '80s – that sort of eco, touchy-feely type of thing wasn't cool at all, but I just loved it. I've always loved the Joan Baez songs in it. I loved Bruce Dern in it. Whilst I don't think [the *Moon* score] is anything like that, it had that touchstone for me. That added to my excitement of the project for me, because I felt like I was actually dealing with people who think very similarly to me, and that sort of allowed me to go with my gut, such as using stuff like the nursery rhyme thing for the discovery of where all the clones are."

This confidence in professionals who know how to deliver afforded room for freedom and experimentation. Duncan's own father was a source of inspiration for a key moment in the movie, as Mansell explains.

"Duncan had obviously not followed his dad into music, but he told me, 'My dad always said, "If you want to make something be weird, just play it backwards," so is there a place where we could play something backwards?' so I said I'd have a look. And we did it when Sam 2 brings back Sam 1 from the rover, and when he gets back into the space station. The music then plays backwards from when he first brought him back. That was kind of fun."

Fun as that process may have been, so much of the score – especially in the second and third acts – is infused with a deep sadness. As revelations unfold about who the Sams actually are and their place – or, indeed the absence of a place – in the world and their family's life, the music helps enormously in showing these clones have emotions as powerful as any human. The beauty and romance of space and the hopes and fragility of humanity pour from the screen thanks to what is seen, what is heard, and what is felt. It is this that marks *Moon* out as a film that is both deeply intelligent and deeply meaningful.

"I gravitate towards those [types of films]. I like that emotional palette – I mean, when it's genuine, anyway. There's a lot of ideas in *Moon*," reflects Mansell. "From a musical point of view, I can't force an emotion on a film that isn't there or they're not trying to reach for, because it would just look hackneyed at that point."

The emotional apex of the movie is Sam 1's conversation in the rover via satellite link with Eve. This is the moment where he sees his daughter is now fifteen years old, and learns that his wife is long dead. The scene is scored to 'Memories', arguably the centerpiece of the whole soundtrack; a song that works by itself, but is most impactful when paired with the image of Sam 1 in the rover, far from home.

It is also Mansell's favorite, he says. "Not just because I like the piece, but just where it comes in the film. I was quite pleased with myself when I wrote that bit. I remember writing it in a hotel room in London... It's a film that inspired ideas, because of the performers, because of what the script is saying, and the sub-text of it. To some degree it was an easy one, because it was kind of all there for me." And that piece, like *Moon* overall, is still one that resonates all these years later.

The score was released on vinyl and has gone on to have an extraordinary life in the time since the film first showed in cinemas. "The melodies that I used are pretty simplistic, but it's one of my most popular scores," Mansell summarizes. "Something like the 'Memories' theme, I really get a lot of feedback on that, and here we are ten years later. I actually got a royalties statement this morning, and *Moon* outstrips, not everything, but the other things that were part of that same era, probably by about 100/1. By that I don't mean to say I'm getting millions of dollars, just that it's a popular score, and it's a popular film, and it's popular because it's good and it speaks to people. That was the great thing, like having that time and getting to know the people I was working with and what they were about that allowed me to join in with what they were doing."

 GERTY
 Sam, can I help you with
 something?

 SAM 1
 Not now, Gerty, okay?

 Gerty settles into his station. Sam turns to him.

 SAM 1 (CONT'D)
 Gerty? Why did you help me? With
 the password? Doesn't that go
 against your programming or
 something?

 GERTY
 Helping you is what I do.

 Sam 1 heads towards the airlock.

 Sam 1 goes on picking up equipment, shoves it all into a
 backpack he swiped from a peg.

 Sam 2 appears from the return vehicle corridor. *

 SAM 2
 What's going on?

 SAM 1
 There's something I've got to do. *

118 OMITTED 118

119 I/E. SAM 1'S ROVER/MOON SURFACE -- DAY 119

 Sam 1 at the wheel, flooring the Rover -- he looks
 possessed, determined -- a man on a mission --

 WIDE SHOT

 Sam's Rover approaches one of the many Jammers that we now
 know circle the perimeter of the base.

 Sam 1 stops the Rover on the other side of the Jammer.
 Here, outside the range of the Jammers, he figures he might
 be able to get a signal through to Earth.

 ON SAM as he removes his equipment from the backpack and
 starts to uncoil wires -- inserts a small BATTERY PACK onto
 the back of the VP, sits the VP on his lap.

The VP resembles a Play Station Portable with its small but
nonetheless high-quality screen.

Sam isn't sure who to contact at first...finally he enters
some numbers from memory. The VP shaking in his hands. He
is nervous, scared. He disables the video mode on his end,
so he is only sending audio.

A moment of silence. The VP seems dead.

 SAM 1
 Come on...come on...

Then the VP BEEPS -- the monitor BLIPS -- the message seems
to have gone through.

And suddenly a GIRL appears on the screen.

Sam 1 can't believe it. It's the same Girl from his
hallucinations. Same wheat-colored hair. Same freckles
dotting her cheek bones. ~~Same yellow dress~~.

The moment Sam 1 sees the Girl he thinks -- naturally --
that he's imagining things again. But then she speaks:

 GIRL
 Hello?

That's never happened before. Sam 1 finally manages to
respond:

 SAM 1
 Uh, Bell residence?

The conversation has a very slight delay, maybe a second or
two, and the Girl isn't completely clear on the monitor. We
assume that these minor technical glitches are the same on
the Girl's end.

The Girl is sweet, chirpy -- nothing like the haunting,
ghost-like figure from Sam 1's hallucinations.

 GIRL
 This is the Bell Residence.

 SAM 1
 I'm trying to reach Tess Bell.

The girl's expression shifts -- now somewhere between
melancholy and curiosity --

 GIRL
 I'm sorry, she passed away some
 years ago.

Sam 1 GASPS. He literally gasps. Like someone just plunged
a paring knife into his belly.

SCX6

MCU
EVE BELL
(VIDEO PHONE)

OV 1+2

 SAM 1
 No...no way.

The girl just stares.

 SAM 1 (CONT'D)
 Tess Bell? Are you sure?

 GIRL
 Uh, yeah, I think so. I'm her
 daughter.
 (then)
 Can I help you?

And astonishingly, the news of Tess's death actually takes
a back seat as Sam 1 is forced to confront this new
revelation.

The girl is EVE BELL. Sam 1 is talking to his DAUGHTER.

Sam 1 tilts his head, a smile twitches on his face.

 SAM 1
 Eve?

Sam 1 can't believe it. She's beautiful. She's beautiful.

 EVE BELL
 Yes?

A moment. Eve distracted by her console, trying to work out *
why there is no image on her end and such a weird delay. *
Tears glistening in Sam 1s eyes. *

 SAM 1
 (overwhelmed)
 Hi... Hi. Eve. How old are you
 now?

For a second Eve is embarrassed -- she blushes slightly --
but is still pulled in, intrigued.

 EVE BELL
 I'm fifteen.
 (then)
 Do I know you?

 SAM 1
 How did mom die, sweetheart?

 EVE BELL
 Uh...

Now Eve is beginning to look spooked. She turns away from
the screen and calls to someone in another room:

MEMORIES CLINT MANSELL'S SCORE

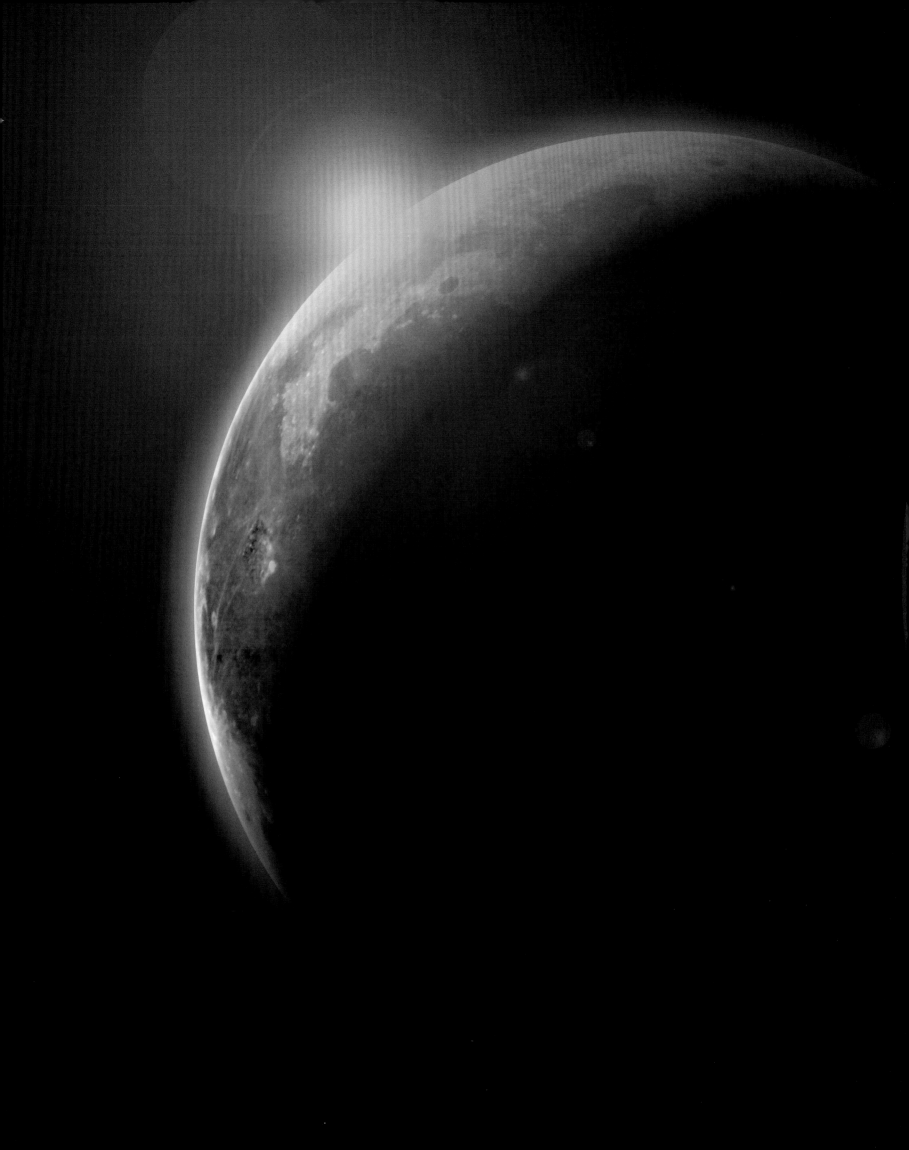

MOON SHINES

RELEASE AND RECEPTION

MOON SHINES
RELEASE AND RECEPTION

Moon premiered at the Sundance film festival in January 2009. The movie had come together incredibly quickly, with a turnaround that is almost unheard of for a first feature, with a high concept and starring a major Hollywood actor. It had been a whirlwind and a scramble for money, stage space, actor availability, visual effects, and so much more. And yet, essentially, it had all gone according to the original plan. The team had achieved what it had set out to achieve, within the time allotted.

"Duncan and I were in Sundance, which would have been January 2009, and it was only one year after starting shooting," confirms Stuart Fenegan. "We started shooting in January 2008 and we were premiering in Sundance in January 2009. That was shocking, and marvelous, and special."

"It was a very exciting time," recalls Sam Rockwell. "We were very nervous, we didn't know if we could pull it off, but we did. It was really an amazing journey to take with Duncan. Seeing it for the first time was fucking wild, man. It was really something. It was pretty magical."

Amidst a strong Sundance lineup, with premiers including *In the Loop* and *The Messenger*, *Moon* stood out as something mysterious and unique: a mostly British low-budget sci-fi movie. It was at this screening that the buzz truly began that carried it all the way to the eventual cinema release in June 2009. Distributors who had chosen not to partner on the film a year ago were suddenly interested, albeit too late.

"The advance screening had got such an amazing response from the press and critics that I was getting all these calls about distribution," explains Fenegan. "It was frustrating having to say, 'We pitched this to you a year ago and you passed.' With that amount of interest from multiple distributors, we could have made a lot more money for the US territory if we'd sold it after Sundance, but I needed to sell that North American territory in advance in order to close the finance for the movie. Not to mention that its good to work with partners that believe in the project from the very beginning, like Sony did.

"First rule of producing: Get the movie made! So make the best deals you can at the time you have to make them."

BELOW: 4 unused poster concepts for *Moon*'s US theatrical release.

The Sundance screening was a highly prestigious event and affirmation that all the hard work and long, *long* days had paid off. In the audience that day was the film's screenwriter, Nathan Parker, who remembers his initial reaction: "I was blown away by the film the first time I saw it. I felt extremely proud – and extremely lucky – to be part of it. One thing I was a little unsure about was how the visual effects would look, only because I knew the film had been made for such little money – pennies, in Hollywood terms. But the film looked amazing, nothing about it seemed cheap. In fact, if you'd added $20 million to the budget you'd barely know where to put it (although I'm certain it would have made Stu's job a lot easier); everything on screen seemed perfect. I also have to give a shout out to Clint Mansell's beautiful score, which made a huge impression on me when I first watched the film."

With that first screening over with, the next job was getting the movie out into the world and to get it in front of the largest audience possible. Fenegan and Jones found themselves in a strong negotiating position, as Fenegan explains. "We were in Sundance getting all these amazing responses and we basically sat down with Sony Classics and said to them, 'We want you to release the film theatrically and no one else can because it's already a Sony movie,' so they agreed to take a look. It was a really tough few days in the middle between the initial press and industry screenings and the big public premiere screening at the end of the week."

ABOVE LEFT: Duncan Jones with his BAFTA award for Outstanding Debut by a British Writer, Director or Producer.

ABOVE RIGHT: Norwegian and Russian theatrical release posters for *Moon*.

What followed was a slow rollout, with the film gaining more and more positive word-of-mouth and stopping off at other festivals, such as Tribeca in April and Edinburgh in June. Any concerns that the movie would go straight to DVD disappeared and *Moon* hit theaters in New York and Los Angeles via Sony Pictures Classics on 12 June 2009. The UK followed suit in July, with an Australian release acting as a victory lap in October.

The industry reviews were overwhelmingly positive, with many singling out Sam Rockwell's performance, the film's themes, and the thoughtful, controlled direction despite its low budget. Roger Ebert granted it three and a half stars out of four, while A.O. Scot of *The New York Times* highlighted its "impressive technical command" and "density of moods and ideas." Even NASA praised the film's adherence to a grounded reality.

As the year drew to a close, *Moon* appeared on many critics' end-of-year lists, and received a multitude of awards nominations. These nominations – and wins – were not limited to science fiction competitions, with the London Film Critics' Circle Awards naming Duncan Jones British Director of the Year and BAFTA awarding him for Outstanding Debut by a British Writer, Director or Producer. In his acceptance speech, Jones said, "Finally I think I've found what I love doing."

The acclaim that greeted the film made Duncan Jones and Stuart Fenegan suddenly talents everyone wanted to know. The next step, the sophomore feature, for any filmmaking team can be just as crucial as the first.

BELOW: Stuart Fenegan, Sam Rockwell, Sting, Jones and Trudie Styler at the Sundance screening after-party.

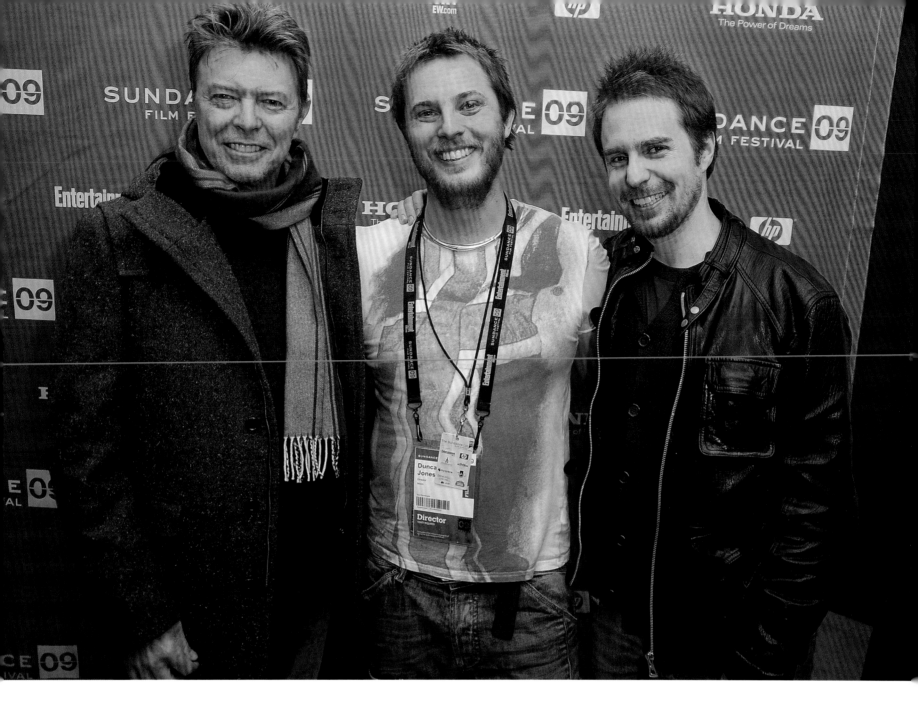

"In the immediate aftermath of that successful Sundance screening suddenly we were getting incoming calls from American agents interested in representing Duncan and talking to us about other projects," says Fenegan. "I remember sitting in Utah with Duncan and saying to him, 'Wow, that's fantastic and awesome, but this must happen every year,' hot directorial debut bun fight for the new talent. So I'm like, 'We'd better get a second movie sorted in the next twelve months, otherwise there's going to be another crop of new, exciting directors and we might miss that window.' I remembered telling Duncan, 'We're probably not going to

develop the next idea in time for production in twelve months, so I really want to find a script for us and be in production in the next twelve months.' Again, naivety is a powerful weapon and has been all the way through my producing career, because that was such a ridiculous statement to have made. But, lo and behold, it did actually come to pass. I remember sitting in my production office in Montreal, in the snow of January 2010, shooting *Source Code* – another piece of independent intelligent sci-fi – feeling quite smug, and having a cup of tea in the cold with Duncan, going, 'Well, we did it within twelve months – that was good!'"

ABOVE: David Bowie, Jones and Rockwell at the Sundance Film Festival.

SAM ROCKWELL

250,000 MILES FROM HOME,
THE HARDEST THING TO FACE...
IS YOURSELF.

MOON

A SONY PICTURES CLASSICS RELEASE A LIBERTY FILMS PRODUCTION IN ASSOCIATION WITH XINGU FILMS AND LIMELIGHT SAM ROCKWELL "MOON" DOMINIQUE McELLIGOTT
KAYA SCODELARIO BENEDICT WONG MATT BERRY MALCOLM STEWART CASTING DIRECTORS JEREMY ZIMMERMANN AND MANUEL PURO MAKE-UP AND HAIR DESIGN KAREN BRYAN DAWSON
COSTUME DESIGNER JANE PETRIE CONCEPTUAL DESIGN GAVIN ROTHERY PRODUCTION DESIGNER TONY NOBLE VFX & CHARACTER ANIMATION BY CINESITE DIRECTOR OF PHOTOGRAPHY GARY SHAW MUSIC BY CLINT MANSELL
EDITOR NICOLAS GASTER LINE PRODUCER JULIA VALENTINE EXECUTIVE PRODUCERS MICHAEL HENRY BILL ZYSBLAT TREVOR BEATTIE BIL BUNGAY CO-PRODUCERS NICKY MOSS ALEX FRANCIS
MARK FOLIGNO STEVE MILNE STORY BY DUNCAN JONES WRITTEN BY NATHAN PARKER PRODUCED BY STUART FENEGAN TRUDIE STYLER DIRECTED BY DUNCAN JONES

SONY PICTURES CLASSICS™

WWW.MOON-MOVIE.COM WWW.SONYCLASSICS.COM

MAKING MOON A BRITISH SCI-FI CULT CLASSIC

Mom died of cancer. I mean, it
was in the family. Who knows? Or
maybe it was an accident? Could
have been a million things.

SAM 1
I wish I'd been there.

SAM 2
Yeah. Me too.

The two Sams sitting together, UNITED by their grief.

OPPOSITE: *Moon's* US theatrical
release poster.

ABOVE: A section from Jones's
shooting script.

"I'LL NEVER FORGET THIS: I'M BACKSTAGE AT THE ECCLES THEATER
AND SAM IS PACING UP AND DOWN ON HIS OWN NEXT TO THE GREEN
ROOM. I SAID TO HIM, 'ARE YOU ALL RIGHT, SAMMY?' AND HE GOES
'YEAH, MAN, I'M ALL RIGHT, I'M ALL RIGHT.' AND I SAID, 'ARE YOU SURE?'
HE GOES 'YEAH… IT'S JUST A LOT OF ME. EVERYONE'S GOING TO BE
WATCHING A LOT OF ME FOR AN HOUR AND A HALF.' I SAID, 'BOTH OF
YOU ARE AWESOME IN THIS MOVIE – IT'S GOING TO BE GREAT!' IT WAS A
REALLY SPECIAL MOMENT, WHERE SAM BECAME SO ACUTELY AWARE OF
HOW MUCH THE MOVIE HUNG ON HIM AND HIS PERFORMANCE. IT WAS
REALLY CHARMING TO SEE HOW EXCITED AND NERVOUS HE WAS."

STUART FENEGAN *PRODUCER*

WHERE ARE WE NOW?
TEN YEARS LATER

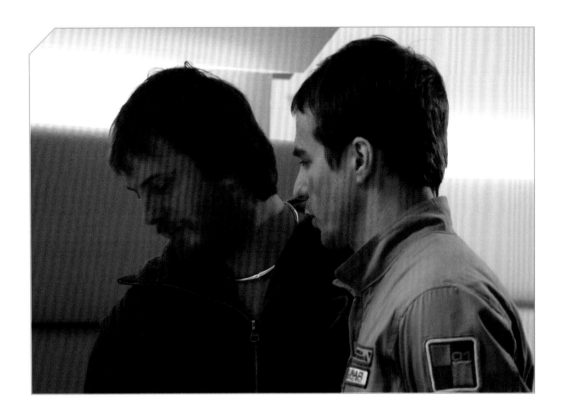

hilst established critics and the media at large greeted the film with strong notices, it was the fans who really gave *Moon* its longevity. Almost immediately, and certainly in the years that have passed, devotion from viewers all over the world has ensured *Moon*'s legacy. No 'Best Sci-Fi Films of the 21st Century' list is complete without it, and it has gone from being a cult space oddity to part of the science fiction pantheon.

The effect on the cast and crew has been significant. Aside from the memories, working relationships, and friendships that came as a direct result of those months on the movie, many saw their careers boosted by this small film with big ideas.

"A lot of what I've worked on since has been because of *Moon*," confirms production designer Tony Noble. "I did a film with Xavier Gens called *The Divide*, and he said he came to me because of *Moon*. It was like a family gathering. We were all in it together. You had to be. Because we didn't have the time or money, you had to get it right first time. You couldn't screw around or say, 'We'll do it a hundred times.' I've never known a film to be thought of so affectionately. I think that's amazing."

For composer Clint Mansell, he can see a direct correlation between his work in 2008 and today, as songs he composed for *Moon* are still requested for use in other formats. Music can linger long in the memory, sometimes far longer than an image, and many fans are still haunted by the score.

ABOVE: Duncan Jones and Sam Rockwell on the moonbase set during the *Moon* shoot.

OPPOSITE TOP LEFT: Robin Chalk and Rockwell on the moonbase set.

OPPOSITE TOP RIGHT: John Lee on the miniatures set.

OPPOSITE BOTTOM: Jones on the moonbase set.

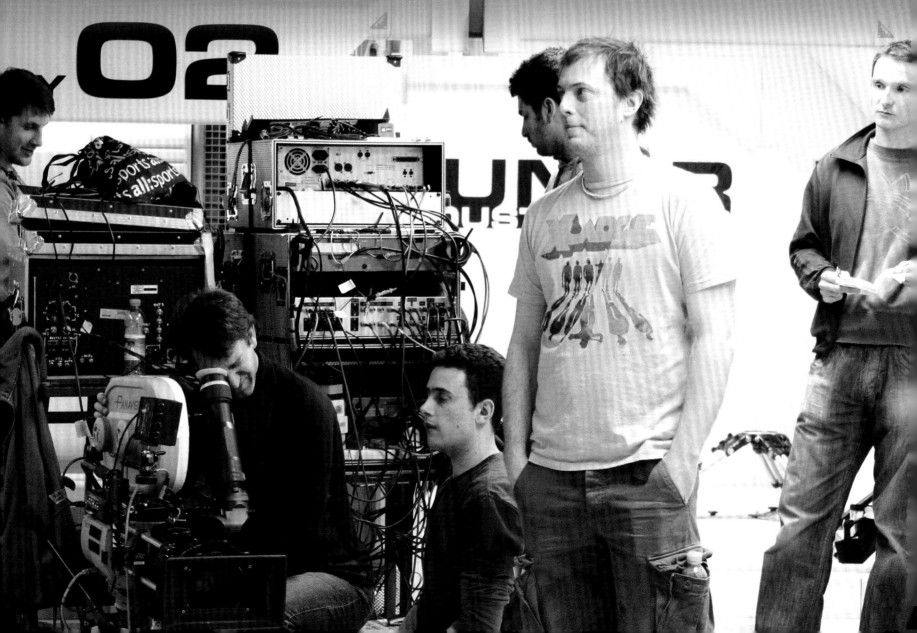

"I THINK THE LONELINESS IS MUCH MORE PALPABLE IF YOU CAN SEE EARTH, WHICH IS WHERE WE HAVE THAT SHOT THAT I LOVE WHERE SAM IS IN HIS ROVER, LOOKING BACK AT THE EARTH, CALLING HIS DAUGHTER. YOU CAN'T DO THAT MOMENT IF YOU'RE IN A SPACESHIP, OUT PAST THE EDGE OF THE SOLAR SYSTEM. IT FEELS COMPLETELY DISTANT. BUT TO ACTUALLY BE ABLE TO SEE THE PLACE WHERE YOU WANT TO BE IS MUCH MORE POWERFUL."

DUNCAN JONES *DIRECTOR*

"*Moon* is really up there with what I think is my best work, I really do," Mansell says. "I think it's because of all the great work everybody else did, but also finding people that allowed me to be me. Not that I could just come in and do whatever I liked, but you come with these ideas and you're helped to make them work... That's success to me – that your collaborators and yourself are invested in and happy with what's been created, and then people respond to it and enjoy it and get it. I think *Moon* can hold its head up as helping to bring along this new wave of science fiction that we've seen over the past few years, and that's because it's really good."

So good, in fact, that film students now study it, dissecting everything from the costume and set design to the miniatures work, something senior model maker John Lee has experienced firsthand. "Everyone I currently work with, including students, is always complimentary when I say I worked on it, so I know it's a special film" he says. "There were only a handful of us in the model unit, so our work does stand out and actually plays a big part in the film. Films like *Moon* don't come along that often, and with the current trend of CGI, we may not see a film like this ever again. With *Moon*, you get to appreciate the special effects, and realize they are real, or as real as we could make them."

Similarly, people still commend model shop supervisor Steve Howarth for his effects work on the film. Even inviting him to WonderFest in Louisville for the sole purpose of leading a seminar on how to weather props "the *Moon* way."

For Howarth and so many of the crew, it is the story and Sam Rockwell's performance that stay in the mind longest. "I knew it was quality, serious adult sci-fi," Howarth states. "There won't be another one like it. I've never met anyone who doesn't like it. Sam pulls you in and sells it from the beginning."

"I wouldn't say anything changed immediately, but there was a cumulative effect with *Moon*," Sam Rockwell says of the film's legacy. "It was part of a new renaissance of smart sci-fi, like *Children of Men, Ex Machina, Black Mirror*. I think we contributed to this new clawing back of smart sci-fi."

"Working with Sam one on one for six weeks – what a masterclass! Who else has done that?" says Robin Chalk. "We keep in touch and regularly text each other. I remember at the cast and crew screening,

BELOW: Sam 2 approaches the crashed rover.

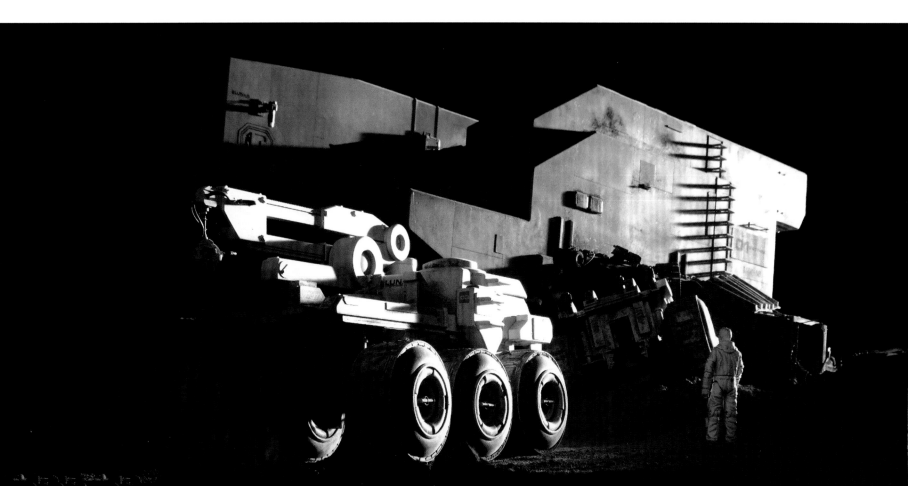

ABOVE: *Warcraft* teaser poster and *Source Code* theatrical release poster.

a friend turned to me and said, 'This is the reason we got into acting. To be involved in original, thoughtful filmmaking.'"

Seeing the work that was put in up on the big screen, the affirmation that this is a *film* – not to mention a classic one – is an achievement in itself. Nathan Parker has seen several of his scripts make it through production, but *Moon* still holds a special place on his resume. "*Moon* has been incredible for my career," he says. "I'm very lucky to have worked on a screenplay that was made into a film, and even luckier that the film turned out to be so successful. I've written many more screenplays, and one or two have even been made into films, but *Moon* is the script I'm known for. *Moon* also ignited my love for science fiction. Most of my original ideas now are in the sci-fi realm, or at least 'futuristic.' I'm so glad all the elements came together, that I met Duncan and Stu when I did and was able to be part of this film."

The film was infamously not nominated for the Academy Awards, but in 2018 its main star received arguably his overdue statuette. Sam Rockwell won Best Supporting Actor for *Three Billboards Outside of Ebbing, Missouri*, and while it

is hard to draw a direct line between that and *Moon*, what *Moon* nonetheless did was present a showcase for him, offering an example of his incredible focus and versatility as an actor.

"*Moon* is a big deal for me," says Rockwell. "I could go on and on about it. There were so many challenges, but it was an amazing experience. I'm very proud of the movie. Duncan and I are very proud of it. It's a major milestone in my career."

"Working with Sam Rockwell is one of the most amazing experiences I've ever had," states costume designer Jane Petrie. "He's my favorite actor to work with so far in my career. There's something absolutely magical about him."

At the time of writing, conceptual designer Gavin Rothery is prepping his first feature film as director. For Stuart Fenegan and Duncan Jones, *Moon* was followed in quick succession by *Source Code, Warcraft,* and *Mute* – the latter reuniting them with some key players from *Moon*, including director of photography Gary Shaw, Clint Mansell, and, in a cameo role, Sam Rockwell. In the case of *Source Code*, it followed *Moon* in extremely quick succession and was seemingly pre-destined.

"Duncan and I had already talked about moving to L.A., but neither of us wished to do so with just commercials under our belt," explains Fenegan. "We wanted to do it after we'd made a movie, so we moved to L.A. straight after *Moon* had come out, and within a couple of weeks we'd signed with CAA (Creative Artists Agency). They said Jake Gyllenhaal saw *Moon* and really liked it and would be up for a general meeting. So Duncan had a coffee with Jake and got on, and at the same time I'm reading dozens and dozens of scripts trying to find a thing for Duncan and I to do within twelve months. I read *Source Code* from The Mark Gordon Company and really liked it. I remember scribbling on the back: 'It's *Quantum Leap* meets *The Hurt Locker* meets *RoboCop*.' I sent it to Duncan and said, 'You must read this. It's good.' And at the same time I'm speaking to Mark Gordon and he said, 'Jake Gyllenhaal's attached to star and we just need a director that Jake will approve and we're off to the races!' Duncan read the script, really liked it, and said he was up for doing it. Mark Gordon went to Jake and said that Duncan Jones was interested. Jake had made a list of five directors he'd be interested to do this with and Duncan was one of those

guys. Boom! It was lightning in a bottle twice for us: first *Moon*, then *Source Code*. I'd like to find some more lightning and shove it into some more bottles as quickly as I can."

Time has been very kind to *Moon*. There is nothing in the references or techniques used that dates it and increasingly it seems miraculous that it got made at all. In 2007-2008 it was hard enough to get funding for a low-budget genre debut movie, but getting such a thing released in theaters around the world nowadays seems akin to the moon landings themselves – an incredible accomplishment, and one tinged with nostalgia. Jones has hinted at a third part of a loose trilogy encompassing *Moon*, *Mute*, and an unrevealed finale, but *Moon* stands alone, proudly in its place as part of sci-fi cinema and as one of the strongest debuts in British film history.

In 2018, supervising prop-maker Bill Pearson's mother passed away, but before she did, he gave her a copy of *Moon* to watch. "My mother was a great sci-fi fan. Ninety-four years old, watching it in Glasgow. I spoke to her afterwards and she said, 'That's a smashing film. What a good story.'"

For a film about clones, it has no imitators. It is the one and only.

BELOW LEFT: *Mute* Netflix poster.

BELOW RIGHT: Sam Rockwell's cameo in *Mute*.

OPPOSITE: A section from Jones's shooting script.

MAKING MOON A BRITISH SCI-FI CULT CLASSIC

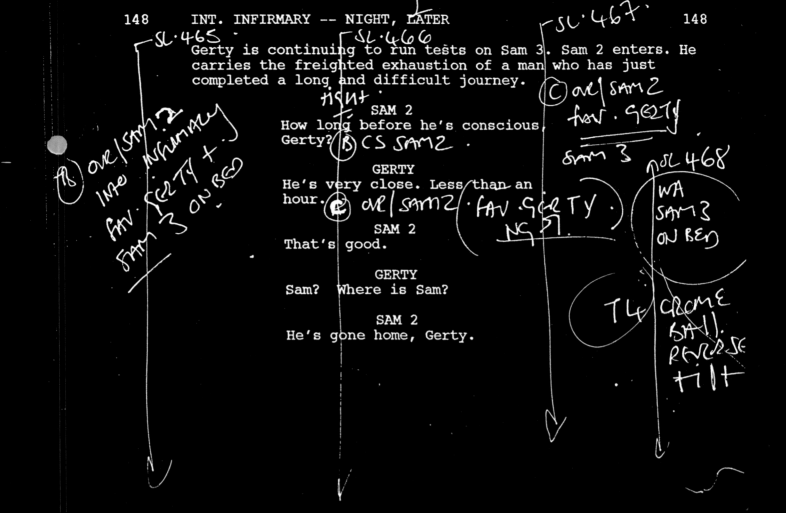

Gerty is continuing to run tests on Sam 3. Sam 2 enters. He carries the freighted exhaustion of a man who has just completed a long and difficult journey.

SAM 2
How long before he's conscious, Gerty?

GERTY
He's very close. Less than an hour.

SAM 2
That's good.

GERTY
Sam? Where is Sam?

SAM 2
He's gone home, Gerty.

"I THINK *MOON* IS ABOUT A LOT OF THINGS, BUT I'LL GO FOR THE BIG ONE. AT THE RISK OF SOUNDING TRITE, *MOON* IS ABOUT IDENTITY AND WHAT IT MEANS TO BE HUMAN. WHEN IT COMES DOWN TO IT, YOUR MEMORIES AND THE PEOPLE YOU LOVE ARE CRUCIAL ELEMENTS OF BEING HUMAN (AND ALSO FEELING HUMAN); THEY GIVE LIFE PURPOSE AND KEEP US GOING."

NATHAN PARKER *SCREENWRITER*

ACKNOWLEDGEMENTS

DUNCAN JONES: Bloody hell. That was a lot of work, wasn't it Gerty?

GERTY: It certainly was. Every single person on that film worked their arses off.

D: We did. I almost died falling off a scaffold tower.

G: You've got the scar to prove it. Would you do it again?

D: Fall of a scaffold tower? Well, not intentionally...

G: No. Go through all that effort to make a movie like *Moon*.

D: Yes. I think we all would. It was a very special film to be part of. And it was a very special group of people who came together to make it.

G: You should probably thank them.

D: Absolutely. Thank you to everyone who made *Moon*. From the bottom of my heart. Thank you for being a part of of something we can honestly all be proud of. I feel a little emotional now...

G: I understand. Maybe I can get you something. Are you hungry?

"THERE WERE HUNDREDS OF AMAZING, TALENTED PEOPLE, THAT MADE OUR DEBUT FEATURE FILM WHAT IT WAS. FROM LONG TERM COLLABORATORS BARRETT HEATHCOTE AND NICKY MOSS IN THE TRENCHES EVERY DAY, TO TREVOR BEATTIE AND TRUDIE STYLER WHO WERE SO BOLD AND UNFLINCHING IN THEIR SUPPORT, TO RHONDA PRICE AND SAM ROCKWELL FOR TAKING THAT GIANT LEAP, DAVE BISHOP, LARA THOMPSON AND LIA BUMAN THEN AT SONY FOR SAYING YES, MY PARENTS BRINGING ME UP TO BELIEVE I COULD BE A FILM PRODUCER IF I WORKED HARD ENOUGH, TO MY TWINS VIENNA AND CAMPBELL WHO TOURED THE MOON BASE STILL IN THEIR MAMA'S BELLY AND WERE BORN DAYS BEFORE THE MODEL MINIATURE SHOOT... TO EVERYONE THAT TOUCHED THIS FILM AND MADE IT WHAT IT WAS, THANK YOU, THANK YOU, THANK YOU."

STUART FENEGAN